Living Through History

# THE ENGLISH CIVIL WAR

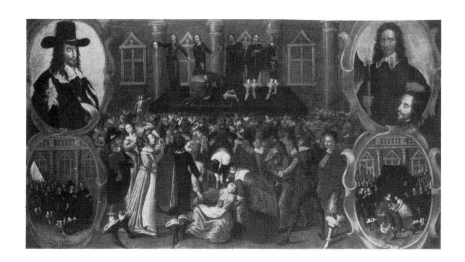

# LINDA MENDES

B.T. Batsford Ltd  London

## ACKNOWLEDGMENTS

The Author and Publishers would like to thank the following for kind permission to reproduce illustrations: British Library for figures 11, 18, 36 and 45; the Trustees of the British Museum for figure 28; Mary Evans Picture Library for figure 52; Mandel Archive for figures 5, 7, 12, 17, 24, 25, 26, 31, 33, 34, 40, 46, 48, 51, 53, 55, 56 and 57; Mansell Collection for figures 1, 3, 4, 8, 10, 15, 16, 19, 20, 21, 22, 29, 32, 35, 37, 38, 39, 41, 42, 43, 44, 47, 49, 50, 54, 58, 59, 60; National Portrait Gallery for figure 6; Newcastle-upon-Tyne City Libraries for figure 30; Tyne & Wear Museums Service for figure 27 (from the collection at the Laing Art Gallery, Newcastle-upon-Tyne); Board of Trustees of the Victoria and Albert Museum (Crown copyright) for figures 14 and 23. The map on page 6 was drawn by R.F. Brien. The picture research was by Patricia Mandel.

### Cover illustrations
The colour painting is "When Did You Last See Your Father?" by W.F. Yeames (*Walker Art Gallery*); the left-hand engraving shows Charles I with his family (*Mansell Collection*); the right-hand print is of the Battle of Marston Moor, 1644 (*Mansell Collection*).

### Frontispiece
The execution of Charles I. The inset pictures show the last scenes in the King's life from his trial to his death. In the bottom right picture people dash to dip their handkerchiefs in the royal blood, which was considered to be a cure for all illness. (By permission of the Earl of Rosebery. The painting is on loan to the Scottish National Portrait Gallery.)

Typeset by Tek-Art Ltd, West Wickham, Kent
Printed in Great Britain by
R J Acford
Chichester, Sussex
for the publishers
B T Batsford Ltd
4 Fitzhardinge Street
London W1H 0AH

ISBN 0 7134 5569 1

# CONTENTS

# THE ILLUSTRATIONS

# THE COMING OF WAR: "THE VALLEY OF THE SHADOW OF DEATH"

On a grey August evening in 1642 the King's flag was erected at Nottingham, marking the beginning of a civil war which was to divide the country over the next six years and would split whole families into opposing groups. Charles I and his Parliament were at war. The setting of the standard was a miserable occasion. The Earl of Clarendon saw it all:

According to the proclamation, upon the twenty fifth day of August, the standard was erected, about six of the clock in the evening of a very stormy day. The King himself, with a small train, rode to the top of the castle-hill. Verney the Knight-Marshall, who was standard-bearer, carrying the standard, which was then erected in that place with little other ceremony than the sound of drums and trumpets, melancholy men observed many ill presages [warnings] about that time. . . . A general sadness covered the whole town, and the King himself appeared more melancholic than he used to be. The standard itself was blown down, the same night it had been set up, by a very strong and unruly wind, and could not be fixed in a day or two till the tempest was allayed. (The Earl of Clarendon, *Selections from the History of the Rebellion and the Life by Himself*)

Tempers had been running high for many years. Since the reign of the great Elizabeth, Parliament had been asking the monarchs for the right to be consulted and give advice. James I and his son Charles believed in the theory of the Divine Right of Kings, which meant they were especially chosen by God and could do no wrong. "I owe the account of my actions to God alone," said Charles. Both the Stuart kings found Parliament to be an obstructive nuisance and said so quite openly.

With such an attitude it is not surprising that the quarrels became increasingly bitter. Many people agreed with the King but a growing number shared Bulstrode Whitelocke's view that the King did not rule entirely alone.

The Sovereign Power is agreed to be in the King but the King is a two-fold power, the one is in Parliament . . . and the other out of Parliament. (Bulstrode Whitelocke, *Memorial of English Affairs from the Beginning of the Reign of Charles I*, 1853 edition)

Religion played a major part in the quarrels which led to war. Large numbers of people known by the general name of Puritans were not satisfied with the Church of England; they wanted it to be much plainer in appearance and worship. They felt that it was already too much like the Roman Catholic Church and was becoming even more so under the rule of Charles 1's Archbishop of Canterbury, William Laud. What was worse, the wife of Charles I, the Queen of England herself, was a French Roman Catholic Princess. People disliked her and felt that she was a bad influence on the King, leading him into wicked ways. Mrs Lucy Hutchinson (see page 42) expressed the views of many when she wrote about Queen Henrietta Maria. She thought the Queen to be a selfish and scheming woman.

This lady Queen Henrietta Maria being by her priests affected with the meritoriousness [benefit] of advancing her own religion, whose principle it is to subvert [overthrow] all other,

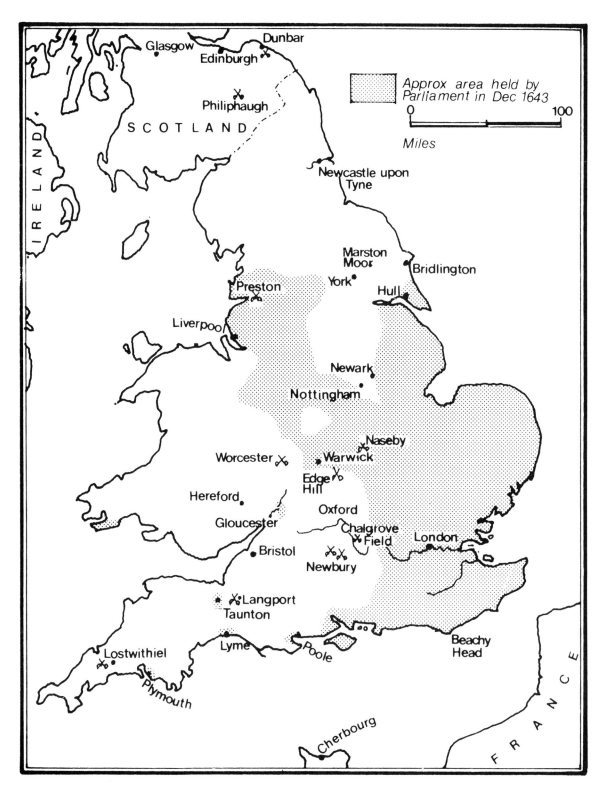

The Civil War.

applied that way here great wit and the power her haughty spirity kept over her husband, who was enslaved in his affection for her, though she had no more passion for him than what served to promote her own designs. (Lucy Hutchinson, *The Life of Colonel John Hutchinson*)

In 1629 Charles had dissolved the third Parliament of his reign, determined never to call it again, and for 11 years he ruled without one. He had the help of the people he trusted most: the Queen; Thomas Wentworth, Earl of Strafford; and William Laud, Archbishop of Canterbury. Many agreed with Lord Falkland when he said they were "The most serene, quiet and halycon [calm] days that could possibly be imagined", but others called these years without a Parliament a tyranny. In 1639 Charles found himself at war with the Scots

**1** This romantic scene, drawn in Victorian times, is called the "Claim for Shelter" and illustrates what must have been a typical dilemma. The Puritan lady on the left is torn between claims of loyalty to her husband and his cause and the plight of the Royalist lady, who might well have been a neighbour and a friend only months before.

**2** The Family of Charles I after Van Dyck. ▶

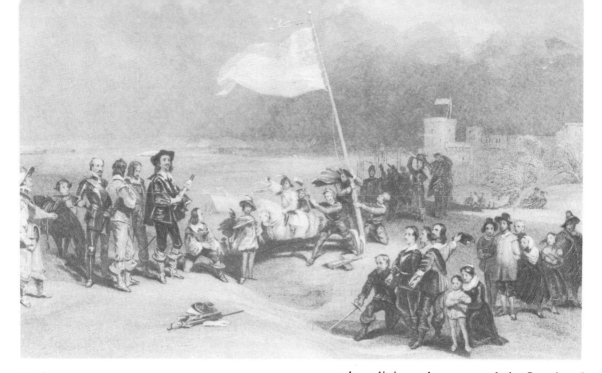

**3** Charles I watches the symbol of war raised with difficulty on a windy August day. The lowering skies and the faces of the onlookers reflect the gravity of this solemn scene.

**4** In this scene Charles I, dressed in the uniform of a soldier, with his battle helmet ready at his side, gives his orders for the coming war. Sir Edward Walker listens eagerly with one hand on his sword as if in readiness for the fight ahead. In the background the troops await them.

over the religious changes made by Laud and himself and was forced to call a Parliament for extra money. By 1642 the "Long" Parliament had removed the "evil counsellors" Strafford and Laud, and had passed laws restricting the King's power. In November 1641 they passed the famous Grand Remonstrance, which amounted to a list of the King's evil deeds and the remedies for them. This was indeed

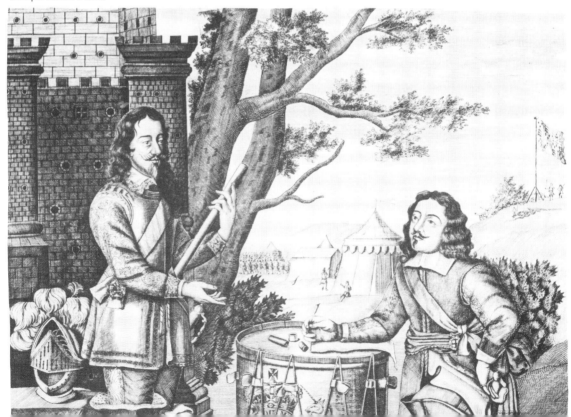

revolutionary and there was great excitement when Parliament voted on it.

It was passed by a mere 11 votes. To many Members of Parliament it was a symbol of the country's freedom. Oliver Cromwell wrote:

If the Remonstrance had been rejected I would have sold all I had the next morning and never have seen England more, and I know there are many other modest men of the same resolution. (Quoted in the Earl of Clarendon, *A History of the Rebellion*)

More alarming for Charles, there was talk that the Queen herself was to be put on trial. Charles could stand it no more. On 4 January 1642 he entered Parliament while it was in session to arrest five Members. This was a serious violation of the privileges of Parliament. A Member recorded the event.

A little after the King came with all his guard and all his pensioners and two hundred or three hundred soldiers to stay in the hall and sent us word he was at the door. . . . Then he called Mr Pym and Mr Holles by Name, but no answer was made.

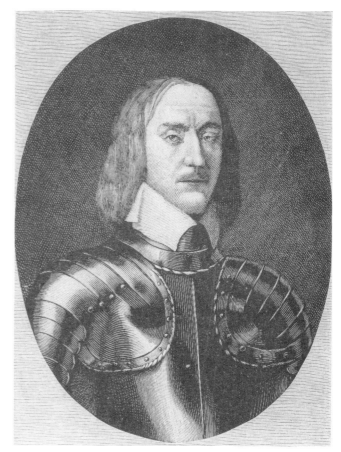

**5** Oliver Cromwell, the man who effectively ruled England from 1649 until his death in 1658. He was given the title of Lord Protector.

To angry cries of "privilege" the King left without the five Members, who, being warned that he was coming, had already fled. For the next seven months King and Parliament tried to get control of the army, supposedly to use for the rebellion in Ireland but really for civil war in England. Charles went to Hull, but the Governor of the city refused him entry. This was a most revolutionary step, but a Parliamentarian said: "If we have done more than our ancestors have done we have suffered more than they ever suffered." England was at war.

The causes of this war were difficult to understand, particularly in an age without mass communication. People took sides for different reasons and there were many people who did not understand the causes at all. In her husband's biography Mrs Hutchinson said of Sir John Gell of Derbyshire,

No man knew for what reason [he joined Parliament] for he had not understanding enough to judge the equity [justice] of the cause.

He was not alone. Although most of the nobility joined the King, and the townspeople were mostly for Parliament, there were people of all classes on both sides. News travelled slowly, and may of the ordinary people were ignorant not only of the causes but, in some cases, even of the war's existence. An agricultural worker, warned off Marston Moor before the battle of 1644, commented, "What, has them two fallen out then?" As the war progressed and year followed year, feelings became bitter. Many people were killed and estates and property lost and destroyed. Neighbours began to hate one another and members of the same families became enemies.

# FOR HIS MAJESTY

I . . . swear before the Almighty and Ever-Living God that I will bear a true and faithful allegiance to my true and undoubted Sovereign Lord King Charles, who is lawful King of this land, and all other Kingdoms and Dominions both by sea and by land, by the laws of God and man and by lawful succession; and that I will constantly and cheerfully ever to the uttermost hazard of my life and fortune constantly oppose all seditions [plots], rebellions, conspiracies, covenants, conjurations [appeals] and treasons whatsoever against his royal dignity, Crown or person raised or set up under what pretence or colour soever.

This oath was taken by those fighting on the King's side. In many ways the King's side was easier to support. The chief attraction was the King himself. After all, he was God's anointed, and many people believed that this fact alone made his cause right. Even some of those who in conscience agreed with the justice of Parliament's cause, or who did not like the King personally, fought for him when the war came. These feelings were well expressed by Sir Edmund Verney in his memoirs:

For my part I do not like the quarrel and do heartily wish that the King would yield and consent to what they desire, so that my conscience is only concerned in honour and in gratitude to follow my master. I have eaten his bread and served him near thirty years, and will not do so base a thing as to forsake him; and choose rather to lose my life – which I am sure to do – to preserve and defend those things which are against my conscience to preserve and defend; For I will deal freely [speak plainly] with you – I have no reverence for bishops, for whom this quarrel subsists [exists].

This noble gentleman did indeed lose his life – in the first battle of the war, at Edgehill in 1642.

There were many who deplored Parliament's "sinful" rebellion against the King. As the hardships of war increased and lives and property were threatened, events made up the minds of many people. One lady who had suffered much wrote of Parliament's cause:

How 'tis for the liberty of the subject to take all from them that are not of their mind and pull down their houses and leave them to the mercy of the unruly multitude, I cannot find [understand]. Nor can I see that it is God's Law.

Some of the King's supporters felt strongly about the religious issue. They disliked the Puritans in all their different sects and saw them as a threat to the whole ancient structure of government. The Church of England and the monarchy were closely linked. As Charles I's father, King James I, had remarked in 1604 when he was faced with Presbyterian arguments against bishops, "No Bishop, no King". There were many who agreed with him. There was also the simple matter of survival, which led the majority of the Church of England and Roman Catholics on to the King's side, especially as the war progressed and the treatment of "Papists" became so brutal.

What of the common people who did not all understand the grand causes of Parliamentary liberty, kingship and religion? Some of them joined the King because their masters fought for him and they often had little choice. Others were taken along by both sides as the armies passed through their towns and villages. Once men had joined the armies of either side it could be difficult to persuade them to stay. Food and living conditions were often appalling. Inspiration from great generals often mattered in this case. The King-had skilled men leading his armies. Montrose in particular, could exercise personal charm over people. It was said of him:

He quickly made a conquest of the hearts of all his followers, so as when he list [wished] he could have led them in chains to have followed all his enterprises. (Quoted in Napier, *Memorials of Montrose: His Life and Times*)

Other reasons for joining one side or the other were less honourable. Local rivalries played a part, and those with old scores to settle often took opposing sides. In every war there are those who see a chance for financial gain from joining one side or another. It must not be forgotten that some people enjoy the excitements war can offer and, for many, to fight on the side of the King offered a more noble prospect.

# Queen Henrietta Maria (1609-69)

The Queen was her husband's most adoring supporter and never ceased to work hard for him. Although many people think that in her interference with state affairs she was more of a nuisance than a help, her devotion to Charles I and his cause is unquestionable. Henrietta Maria was the youngest daughter of Henry IV of France and his Queen, Marie de Medici. Brought up in her father's often violent Court she grew up to be pretty and lively. Her father was stabbed to death while she was still a baby and at the age of 16 she came to England to be the wife of Charles I. Even Mrs Lucy Hutchinson, the Parliamentary Colonel's wife who was usually so unkind to her, was forced to admit:

He [Charles I] married a Papist, a French lady of a haughty [proud] spirit and a great wit and beauty. (Lucy Hutchinson, *The Life of Colonel John Hutchinson*)

Like all marriages between a prince and a princess this was a political match and it did not please all the people, especially the Puritans. There was great suspicion of the new French Queen, who arrived with many foreign servants, some of them Roman Catholic priests. Henrietta Maria did not understand much English and she was bewildered by the customs of her new land. Lonely and increasingly unpopular because of

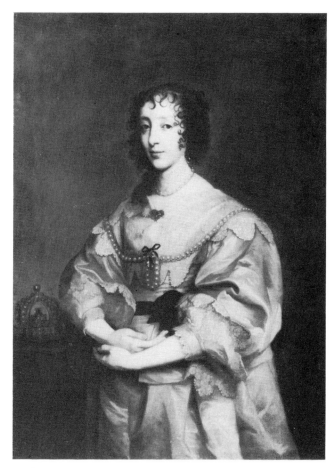

**6** Portrait of Queen Henrietta Maria after Van Dyck.

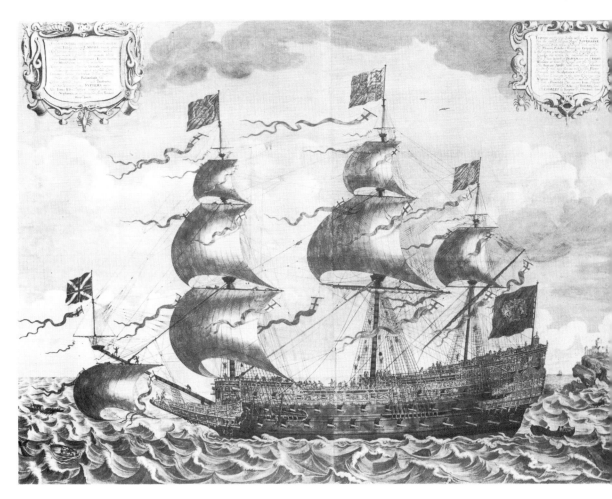

her French company and Catholic ways, she became withdrawn and irritable, even with the King. The Earl of Clarendon noted in his *History of the Rebellion* that many of the future troubles came from all this:

... and it was Her Majesty's and the Kingdom's mis-fortune that she had not any person about her who had either ability or affection to inform or advise her of the temper of the kingdom or the humour of the people, or who thought either worth caring for.

In spite of their early quarrels, however, the King came to love his Queen dearly. When his great friend the Duke of Buckingham, was assassinated in 1628, Charles turned to his wife for comfort and friendship. Henrietta Maria was pleased to be involved in politics and delighted in advising her husband on matters of state, which she had not been able to do in the past. Clarendon noted:

**7** *The Sovereign of the Seas* was built for the Royal Navy in 1637. In such a vessel Henrietta Maria was tossed about on the North Sea on her way to England and again a year later as she returned to France.

When she was admitted to the knowledge and participation of the most secret affairs (from which she had been carefully restrained by the Duke of Buckingham whilst he lived) she took great delight in the examining and discussing of them and from thence making judgements of them, in which her passions were always strong. (*History of the Rebellion*)

The Queen's Puritan subjects strongly disapproved of her. It was known that she loved theatricals and often acted in plays with the King but, more seriously, she was thought to be plotting with her relations in France. During the 11 years when Charles ruled without a Parliament, M.P. John Pym and his friends looked through the records to see if

there was a possibility of putting the Queen on trial. When the Civil War broke out the Queen made a brave decision to leave England, because she knew that Parliament would use her to make Charles give in to their demands. She left in 1642, taking her daughter Princess Mary as a ten-year-old bride for William, Prince of Orange. As soon as she arrived in Holland she set about collecting money for her husband, writing constantly to him, urging him to show strength and courage. She also gave him advice about military matters:

Assuredly God will assist us, and whatever may be said to you, do not break your resolution but follow it constantly and do not lose time. As to sending you that money, I will make all possible diligence [haste], but I do not know where to send it to you. Therefore when you come to York if you find the country well affected Hull must be absolutely had; if you cannot you must go to Newcastle; If you find that not safe, go to Berwick, for it is necessary to have a sea-port for reasons that I will send to inform you.

Her letters to Charles were written in a special code, which the King obviously found difficult to master because she was forced to write:

Be care how you write in cipher, for I have been driven well nigh mad in deciphering your letter. You have added some blanks which I had not, and you have not written it truly. Take good care I beg you and put in nothing which is not in cipher. Once again I remind you to take care of your pocket and not let our cipher be stolen.

Henrietta Maria was trying to sell the Crown Jewels in Holland, but this proved to be a slow and difficult business, because the Dutch would not believe that she had permission to sell them.

She waited excitedly for news from England, which was always delayed. When she thought that Charles was being too weak or slow she was not afraid to tell him so. When she heard that the Governor of Hull, Sir John Hotham, had closed the gates of the city to her son Prince James she wrote to Charles in fury,

You see what you have got by not following your first resolutions, when you declared those of Parliament traitors. Let that serve you as an example; do not delay longer now in consultations; it is actions which much do the work at this hour. I have wished myself in the place of James in Hull. I would have flung the rascal [Sir John Hotham] over the walls or he should have done the same thing to me.

Charles sent her a shopping-list of ammunition to buy in Holland, which by selling her personal jewellery and begging for help, she began to collect together. But she soon ran out of money and, desperately wanting to be with her husband, she landed in Bridlington Bay in Yorkshire in 1643. She was only 30 miles from the King's armies in York

**8** In this Victorian picture the Queen and her attendants hurry ashore at Bridlington while out in the bay enemy war-ships fire at them.

**9** This photograph shows the house in which Queen Henrietta Maria sheltered in Bridlington. The house has since been demolished but a ring presented by the Queen to the lady of the house in repayment for her hospitality is still in the possession of the descendants of the family.

but this proved a very dangerous place to be. She found shelter in a cottage by the harbour but the enemy had seen her. She had a narrow escape but wrote with surprising calm to Charles:

God who took care of me at sea was pleased to continue his protection by land, for that night 4 of Parliament's ships arrived at Burlington [Bridlington] without our knowledge and in the morning, about 4 o'clock the alarm was given that we should send down to the harbour to secure our ammunition – boats which had not yet been unloaded. But about an hour after these 4 ships began so briskly [bombarding] that we were all obliged to rise in haste and leave the village to them. . . . Before I was out of the bed the balls whistling upon me in such a style that you may easily believe that I loved not such music.

The Queen made haste to escape but she was not at all afraid.

I went on foot to some distance from the village to the shelter of a ditch, like those at Newmarket, but before we could reach it, the balls were singing round us in a fine style and a sergeant was killed twenty paces from me. We placed ourselves then under this shelter, during two

hours that they were firing upon us, and the balls passing over our heads, and sometimes covering us with dust.

Nine days later the Queen set off for York. Her anxious friends feared that she might be taken prisoner, while her enemies in London spoke of her leading a Catholic army with a flag showing the Pope. The infuriated Parliamentarians carried out their earlier threat and impeached the Queen in her absence. The Queen was not afraid and ignored all this. She was happy because she was united with her husband and her two sons in the King's stronghold of Oxford. Their happiness was to be short-lived. During the first year of the war Parliament had been improving its armies and had signed a treaty with the Scots, which was to be a great help to

**10** The Queen's stay in England during the war was a hazardous affair. The Parliamentarians knew she was in the country and this picture illustrates one of the numerous anxious occasions when the Queen managed a hasty escape from her enemies.

them. Henrietta Maria found that she was expecting a baby and she became very ill. It was decided that she must leave Oxford and, after a most uncomfortable journey, she arrived at Exeter, where she gave birth to her last child, a girl, called Henrietta by her father, because she looked like her mother. To avoid capture the Queen sorrowfully prepared to leave England again. She wrote to Charles,

I shall show you by this last action that nothing is so much in my thoughts as what concerns your preservation and that my own life is of very little consequence compared with that; for as your affairs stand, they would be in danger if you came to help me and I know that your affection would make you risk everything for that. This makes me hazard my miserable life, a thing which in itself is of very little consequence, excepting in so far as you value it.

Wearing a disguise and suffering great pain, a very miserable Henrietta Maria left England for the last time from Falmouth. After a terrible sea-crossing she arrived in Brittany. She asked for shelter from the French Royal Family. The Queen Regent, Anne of Austria, treated the sick and penniless English Queen with great kindness. When she was better Henrietta Maria began to work for her husband again.

Months of sorrow and strain passed and as the news reached France of Charles' surrender and trial Henrietta Maria begged the English Parliament, through the French Ambassador in London, to let her join her husband. It was not to be. Unknown to the Queen, her letters were not opened in England and only ugly rumours reached her in the last months of 1648 and the first of 1649. The rumours were true. In February she was told that Charles I had been executed, for he had been found guilty.

Being admitted King of England, and therein trusted with a limited power to govern and according to the laws of the land [he had attempted to bring about] an unlimited and tyrannical power. ("Trial of Charles I", State Papers)

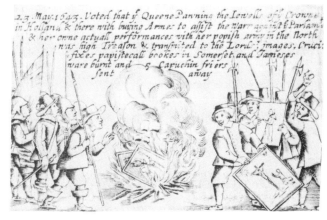

**11** In 1643 the Queen was found guilty of treason. There followed a widespread destruction of Catholic pictures, statues and books throughout England.

Further, he had "waged unnatural cruel and bloody wars".

Sorrowing and ill, Henrietta Maria wrote to her son Charles, the future King Charles II:

Dearest yet most unfortunate son
. . . Losing the title of Queen I have lost all my happiness in this life. I should scarcely know that I am a living woman, were it not for the affliction which, agitating my expiring body, destroys me by degrees . . . and our most loving father, since if I could not have prevented an end so disproportionate to the great worth of such a King, at least I should have had the consolation of accompanying him to prison and to the horrors of death and our spirits, so united in life, would have mutually rejoiced to pass united to another life, where we could have smiled at the charges and wickedness of inimical fortune.

In spite of all this misery she recovered her courage and began to work tirelessly for her eldest son's right to the throne. In the spring of 1660 she had the joy of seeing him set out from Holland for England to claim his throne from his now welcoming people.

Henrietta Maria lived a further nine years, but she spent her last years knowing that her efforts for her family had not been in vain. In April 1669 Lord St Albans wrote to King Charles II:

It hath pleased God to take from us, this morning about 3 o'clock, the Queen, your mother.

# Prince Rupert of the Rhine (1619-82)

Prince Rupert, or "Prince Robber, that Prince of Blood and Lies" as his enemies called him, was the third son of Frederick, ruler of the German state of the Rhineland Palatinate and his English wife, Elizabeth. He was the nephew of Charles I of England and although he was only 23 years old he was already an experienced soldier when the Civil War broke out. It was written of him while he was still in his teens:

His chief delight was in military discipline, wherein he perfected so much under his different tutors for the infantry and the cavalry that at the age of fourteen he was judged worthy of commanding a regiment. (E. Warburton, *Memoirs of Prince Rupert*, 1849)

He had served as a soldier in the Thirty Years' War, fighting to uphold his father's claim to the kingdom of Bohemia, and had spent three years in prison. During this time he met his unusual friend, a dog, probably a poodle, called "Boy", who was to trot into battles with him. In 1642, with the war only months away, his uncle Charles I had written to his young nephew, "In the event of war you will be very welcome to me."

Rupert's first task was to escort his aunt, Queen Henrietta Maria, to France to raise money on the Crown Jewels. He was soon speeding back to England, where he joined Charles for the setting up of the standard. His uncle's generals did not know what to make of this dashing young foreigner and some of them were extremely suspicious of him. His appearance was strange. He was tall for the time, with dark, flowing hair and was always

. . . clad in scarlet very richly laid in silver lace and mounted on a very gallant Barbary horse. He wore a plumed hat, which he did not always exchange for the basnet [a steel cap] in battle. (*Memoirs of Prince Rupert*)

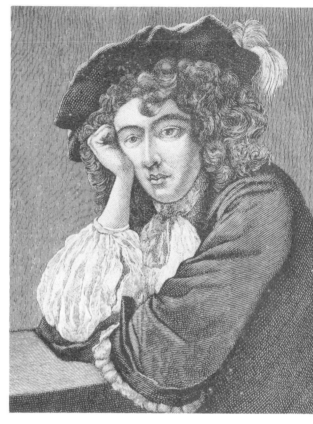

12 Prince Rupert of the Rhine (1619-82). Mezzotint self-portrait. Prince Rupert was one of the pioneers of this art of copper-engraving.

Rupert was young, German and promoted over many of his seniors to become Master of his uncle's horse. It is easy to sympathize with these older and sometimes wiser men, especially when we realize how Prince Rupert reacted to criticism from his own side:

He was not polite to them and took no trouble to gain their affections and he had a little sharpness of temper and uncommunicableness in society, by seeming with a pish to neglect all that another said and he approved not. (*Memoirs of Prince Rupert*)

Although Rupert made enemies among his uncle's senior officers, the common soldiers came to adore him: "He [Rupert], living with the soldiers sociably and familiarly and going with them on all actions."

Rupert brought his experience of the military tactics of Europe to England, and it was not long before he had trained a cavalry which was to be the dread of Parliament's men.

Stories began to spread of the daring of Prince Rupert and his Cavaliers. When he needed money or arms he took them without fear. On one occasion, arriving at Leicester, he found the county magazine had been removed to Bradgate, the home of the Grey family. Rupert rode in and took it, before appearing outside the town. His letter to the Mayor, demanding £2,000 for the King, is an odd mixture of courtesy and threat. His postcript is most menacing:

P.S. If any disaffected [disloyal] persons with you shall refuse themselves or persuade you to to neglect the command, I shall tomorrow appear before your town in such a posture with horse, foot and cannon as shall make you know it is more safe to obey than to resist His Majesty's command.

It was this type of "request" which was to make him the fear of his enemies, but it did not endear him to many on his own side either. Rupert's enemies quickly made him into a type of monster. His activities were related in the most lurid terms possible. In a parliamentary pamphlet published at the end of the first year of the war, it was reported:

Horrible news from Colebrook, Prince Rupert coming . . . on Saturday last – the townspeople having no arms to defend themselves, or to defend their town withal, he plundered it, rifling their houses and imprisoning all those that were

affected to [on the side of] King and Parliament. . .

(Note that those on Parliament's side often spoke of themselves as being for *King* and Parliament, and this was often their battle cry.)

In the first two years of the war Rupert's tactics brought great success for the King. In battle, his cavalry charges mowed down the opposition and his very name brought fear to the towns and castles loyal to Parliament. In this superstitious age it was soon believed by many that he had the devil's help, and his little dog was his supernatural companion. "The devil dog Puddle [Poodle]", they said, could make itself invisible and pass through the Roundhead camps and could also tell the future. The Prince's other pet, one of his mother's monkeys, was also a demon. It wore a green coat and sometimes rode on the back of "Boy".

Perhaps the stories of Prince Rupert's famous disguises gave rise to these odd superstitions. It was true that he seemed to have an uncanny knowledge of the enemy's strength. In a pamphlet called *Prince Rupert and his Disguises*, published by an indignant Roundhead in 1642, Prince Rupert allegedly found himself dangerously near the camp of Parliamentary Commander-in-Chief, the Earl of Essex. He met a man with a cartload of apples and, on being told they were for Essex's army, he enquired why they were not for sale to the King's men. The apple-seller replied: "O they are Cavaliers and have a mad prince

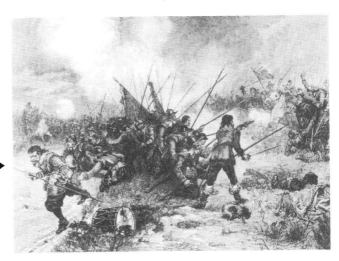

**13** This scene depicts the confusion and noise of the battle of Marston Moor in 1644. After this Royalist defeat Prince Rupert managed to escape by hiding in a bean field while his enemies combed the countryside for him.

among them; and the Devil a penny I could get in the whole army."

Rupert paid him ten shillings for the whole cart and changed clothes with him. He then drove the cart into the enemy's camp near Worcester and sold the apples (at a very good rate). At the same time he was able to see how numerous and strong they were. Having sold all his apples, he trundled the cart back to the man and gave him this message: "Go to the army and ask the commanders how they liked the fruit Prince Rupert in his own person did but this morning sell them."

Such tales, if they are to be believed, could not have hurt Rupert's reputation for daring. However, there is little doubt that he was a very hard soldier and that fear of him was justified. In 1645 when Rupert reached

**14** Letter from Charles I to Prince Rupert. Dated 20th October 1644, it was written while Prince Rupert was in Bristol. Charles was obviously writing in haste but his affection for his nephew is touching.

Hereford he hanged 13 of the townsmen in reprisal for their previous hanging of 13 Irish Royalists. Rupert's military charges could be impetuous and disorganized. His horses could certainly scatter the enemy but they needed to group together again and this could take time.

But not everyone on Parliament's side was in fear of him. In 1644 Oliver Cromwell put his new regiment, the New Model Army, into battle, and on a rainy summer evening at Marston Moor, in Yorkshire, Rupert was defeated. Oliver Cromwell had trained his men to defend steadily. "Old Ironsides", as Rupert called Cromwell and his men, won by holding out. Rupert escaped but many of his men were killed or taken prisoner. Here, one Parliamentarian, seeing his chance, deliberately shot Rupert's faithful dog. The Prince was deeply depressed and wrote in his diary: "I am sure my men fought well and therefore know no reason of our rout [defeat], but this, that the devil did help his servants."

Rupert was wrong: it was not the devil but a carefully trained band of men who had defeated him, and who were to do so again at the fateful Battle of Naseby. Meanwhile Rupert retreated to Bristol, where he set about raising a new army and increased his unpopularity by pillaging the town. He knew that a peaceful settlement with Parliament was essential and the failure of the Treaty of Uxbridge, which had tried to bring this about, was a great sorrow to him.

In 1645 the King decided to lay siege to Leicester. When the city refused to surrender the walls were breached and up to 300 inhabitants slain. According to an observer, "the streets ran with blood". At Naseby the King was thoroughly defeated by the New Model Army and Rupert rode sadly back to Bristol in the hopes of strengthening the King's last stronghold in the west. All was lost on the military front and Charles decided to try and make for Scotland, where Montrose was still winning battles for him. Rupert knew his uncle's only hope was to come to some sort of treaty with his Parliament, as he wrote to the Duke of Richmond:

His Majesty hath now no way to preserve his

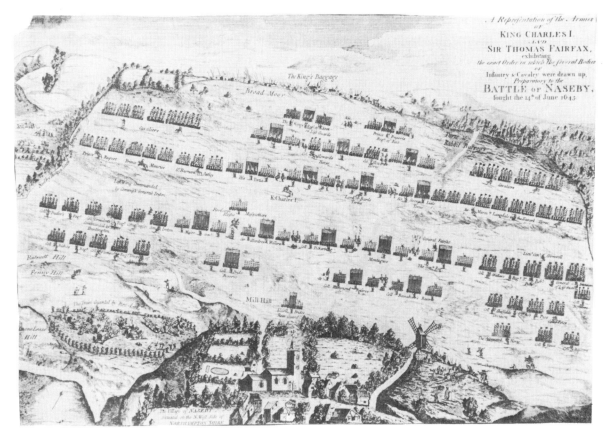

A Representation of the Armies
OF
KING CHARLES I.
AND
SIR THOMAS FAIRFAX,
exhibiting
the exact Order in which the several Bodies
OF
Infantry & Cavalry were drawn up,
Preparatory to the
BATTLE OF NASEBY,
fought the 14ᵗʰ of June 1645

**15** The Armies of Charles I and Sir Thomas Fairfax at the Battle of Naseby. This representation illustrates the formal arrangement of seventeenth-century battles. The village of Naseby is at the bottom of the picture. One wonders how the villagers must have felt to have their rural peace destroyed by two vast armies descending on them.

posterity, kingdom and nobility but by a treaty. I believe it a more prudent way to retain something than to lose all . . . one comfort will be left, we shall fall together.

But Charles would not hear of it.

Meanwhile, General Fairfax laid siege to Bristol and, knowing all was lost, and with a guarantee of safety for his men, Rupert surrendered. In September 1645 Rupert and his army rode out of Bristol in defeat.

On 5 July 1646 Rupert left England with a free pass from Parliament and joined the exiled Court and the Queen. By September Charles, now a prisoner at Hampton Court, wrote to his brave nephew in a letter full of sorrow, apology and forgiveness:

Amongst many misfortunes which are not my fault, one is that you have missed those expressions of kindness I meant you . . . Assuring you that next [after] my children (I say next) I shall have most care of you and shall take the first opportunity either to employ you or have your company.

Rupert spent the next two and a half years at sea robbing Parliamentary ships.

In January 1649 news reached the sad little group of exiles that Charles I had been executed. Rupert wrote in fury:

The bloody and inhuman murder of my late uncle hath administered to me fresh occasion to take vengeance on those arch traitors pretending the name of Parliament. . .

Rupert had certainly not given up. When the war on land was over he took to the sea. His "Sea Cavaliers" were to cause great trouble for the new republic, stealing their ships and ruining their trade. Rupert survived it all and after the Restoration he returned to England. He became Admiral of the Fleet for Charles II, where he helped to work out the

**19**

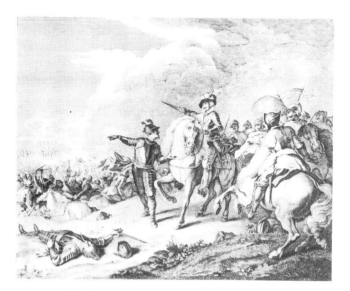

**16** At this point in the battle of Naseby an apparent misunderstanding ended Royalist hopes of victory. Prince Rupert had made his initial charge although heavily outnumbered, but the King was prevented from following by a loyal servant, fearful for his master's life. The King's horse was turned away and the troops, seeing this, followed His Majesty out of the battle. General Fairfax and the Parliamentarians were able to defeat those who remained.

"Fighting Instructions for Naval Warfare", which were to be of such help to Nelson in years to come.

Rupert became a founder member of the Royal Society and famous for chemical experiments and the new art of copper-engraving called "mezzotint". In 1668 he became Constable of Windsor Castle, and his death in 1682 was a great sorrow to all England. Sir Philip Warwick probably summed him up best of all when he wrote:

He put that spirit into the King's army that all men seemed resolved: and had he been as cautious as he was a forward fighter and a knowing person in all parts of a soldier, he had most probably been a very fortunate one. (*Memoirs of the Reign of Charles I*, 1813)

# James Graham, Marquis of Montrose (1612-50)

He accustomed himself to coarse feeding and constant drinking of water . . . so that the want of delicacies should be no temptation to him to weary of the cause. (Funeral oration)

The life and death of James Graham, Marquis of Montrose, certainly reads like an exciting, dramatic story, with its tales of daring adventure and great courage. He was the handsome and intelligent only son in a family of sisters who adored him. According to his friends, he grew up to be sweet-natured and good at both sport and his studies. While at the university of St Andrews he grew to love poetry and wrote some himself, and many tales are told of his skill at golf, archery and swordsmanship. He longed for adventure and set off to study at Angers, in France, which was then the best military college in Europe.

Over a period of three years he visited all the famous sights of Europe and, it was written of him at his funeral, he would have

. . . surveyed the rarities of the East if his domestic affairs had not obliged his return home, which chanced at that time the late rebellion began to peep out. (*A Relation of the True Funerals of the Great Lord Marquis of Montrose*, 1661)

It was these ominous signs at home which marked the end of Montrose's relaxed life of poetry, study and sport. He returned to a Scotland divided by religious strife. Like many Scots, he was a Calvinist and he viewed with horror the attempt by King Charles I and the Archbishop of Canterbury, William Laud, to force the Scots to accept the Episcopal

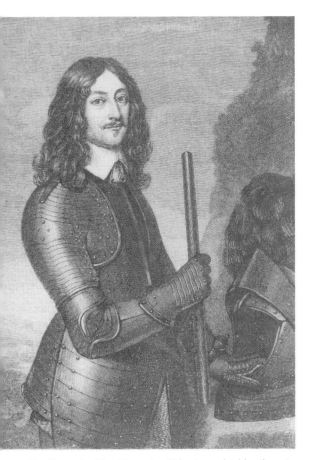

17 Portrait of the Marquis of Montrose by Honthorst.

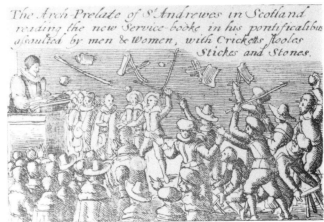

**18** The Scots were violently opposed to the English Prayer Book, which William Laud, Archbishop of Canterbury had insisted they adopted in their churches. This led to scenes such as this throughout Presbyterian Scotland and was to result in the Bishops' Wars.

Prayer Book. Scotland rose in rebellion and thousands signed the famous petition known as the National Covenant. Montrose agreed with all this. He did not think that it was disloyal to the King to protect Scotland's religion. He wrote: "We are disclaimed as traitors and bloody rebels. Answer: traitors we are not, to God, nor King, nor Country."

The Scots Covenanters had formed an army and took control of Aberdeen. Montrose was appalled by the behaviour of the soldiers, especially when they freely robbed the people in the name of religion. This was "plunder", a German word, new in Scotland, which came from the Thirty Years War then raging in Central Europe. Montrose began to wonder if he was on the right side, especially when Charles agreed to the Peace of Berwick in 1639 and promised an agreement with the Scots. Montrose changed sides because he began to suspect the Covenanters' intentions. He wondered whether "these fine pretexts were calculated merely to engage the affections of the ignorant and superstitious rabble and to alienate them from the King".

In vain, Montrose tried to persuade his former friends to mend their ways and return to their old loyalty. In desperation he wrote to them:

Noblemen and gentlemen of good quality, what do you mean? Will you teach the people to put down the Lord's Anointed and lay violent hands on his authority, to whom you and they [the Scots people] owe subjection?

This was exactly what the Covenanters did intend to do. They never forgave Montrose for deserting them and, on a very flimsy pretext, threw him into prison. They did not dare release him, especially when the King came to Edinburgh, because, as his chaplain and friend wrote,

By his wisdom and courage and the great influence he had both with the Nobility and the Commons, he might have persuaded great numbers to be of the same sentiment with himself, for the safety and preservation of the King and the Royal Authority. (George Wishart, *Memorials of James Graham, Marquis of Montrose*, 1660)

Montrose was released because he had done nothing to keep him in prison. He now knew that his mission must be to persuade Charles I to let him subdue Scotland. This was no easy task because the King was under the influence of the Earl of Hamilton, who had persuaded him that the Scots would one day join the Royalists against the rebellious English subjects. It was only in 1643, when the Scots Covenanters signed the Solemn League and Covenant with the English Parliament and a huge Scottish army prepared to come over the border against the King's forces, that Charles at last sent for Montrose and "confessed that he [Charles] now perceived he had been shamefully betrayed by those he had trusted with his crown, honour, life and secrets". He begged Montrose for advice and the Marquis gallantly offered to "reduce the rebels to obedience, of which he did not altogether despair, or lose his life in the attempt".

This was a prophetic statement, for in 1650 Montrose was to die for his support of the King or his "treachery to the Covenant" as his former friends maintained. In the meantime, he set about his gallant mission, which first

needed a large army. Montrose soon found that he was not about to get one. Nobody in England could spare men or equipment for Montrose. As the Earl of Newcastle told him, every day they were expecting the huge Covenanting army to cross the border and needed all they had. Montrose, wanting to be active, decided to help the Royalist forces in the North of England. His success impressed Prince Rupert but did not gain him any arms or men for the fight in Scotland. At first Montrose was very depressed. What could he do with so little? His friends told him to admit defeat, return his commission to the King and flee abroad. Certainly, they told him, nothing more could be done; but it was not in

**19** "The Retreat of Montrose". Montrose is the heroic figure on the white horse. He is frequently outnumbered but the courage and daring of his men succeeded in holding back the enemy in Scotland for a year. On this occasion, at Philiphaugh, he was finally forced to leave the battlefield by his loyal men. Those who surrendered were executed. Montrose would not kill his own prisoners although his men egged him to do so.

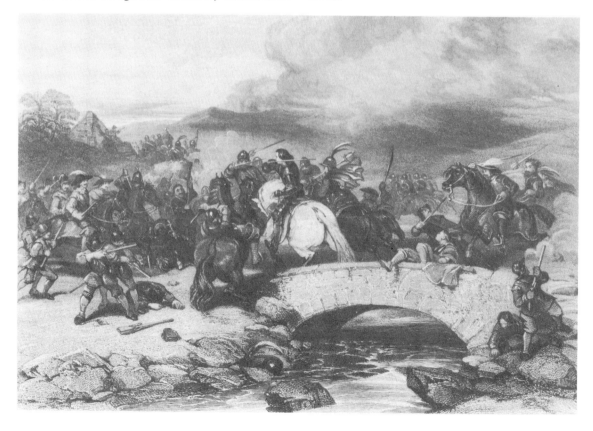

Montrose's character to give up. He thought of a daring plan and his chaplain, George Wishart, recorded:

He afterwards performed such exploits, without men, without money and without arms, which, as they were an admiration to us, who were present and eye witness of them, so they may properly be the objects of imitation to the greatest generals of succeeding ages. (*Memorials of James Graham*)

Montrose had decided to appeal to the loyal and fierce Highlanders. He would join these with a force from Ireland of the Clan Macdonald who had landed in Scotland. With the clans Stewart and Robertson Montrose now had an army of about 2000. They were untrained and badly equipped, having only dirks and swords and, apart from the baggage ponies, only three horses among them. What was more, they were hopelessly outnumbered by the 6000-strong Covenanters. Montrose worked out a daring plan of attack. If they did not have the numbers at least they could have organization and speed. Montrose's fierce and tough band were to have a year of enormous success against all odds. His first great victory at Tippermuir was typical of the style of battle which was to be the terror of his enemies:

He [Montrose] extended his front as much as he could, placing his files only three men deep; and, that they might engage all the enemy at the same time, he ordered the men in the first rank to rest upon one knee, those of the second to stoop, leaning over the first and the last rank in which he placed the tallest men to stand erect. He ordered them likewise to be sparing of their powder of which they were very scarce and not to fire a single musket until they came up to the face of the enemy, and that having once discharged their pieces, they should immediately fall on boldly, sword-in-hand. (*Memorials of James Graham*)

It was to be a winning formula. His men were brave and not afraid of the horrific wounds which could result from battle. At his next great victory at Aberdeen in September 1644 an incident was reported which gives a good example of this legendary bravery:

Among others that were wounded was an Irishman had his leg shot off by a cannonball, so that it hung only by a bit of skin, and perceiving his comrades affected with his disaster, he called to them in a cheerful and encouraging tone, "This, my companions, is the fate of war, and what none of us ought to grudge: go on and behave yourself as becomes you, and as for me, I am certain My Lord the Marquis will make me a trooper as I am now disabled for foot-service." So saying he took a knife from his pocket, and, with his own hand cut asunder the skin without the smallest shrink or emotion, and delivered his leg to one of his companions to bury it. (*Memorials of James Graham*)

The Irishman was right. He recovered and the story tells that Montrose indeed made him a trooper!

Victories continued as Montrose's men marched on, but winter was coming and the few English and Lowlanders in his troop could not bear the thought of marching through the chills of Scotland in December. Undaunted, Montrose and the Highlanders set off into the mountains. They slept in the open and lived on oatmeal, mixed into porridge with the snow. They often marched for days without rest, keeping to the mountain passes, and when they attacked the enemy was completely unprepared.

The long march of Montrose through the mountains has been repeated by many people since, who have marvelled that it could be done in summer, let alone in the depths of a Scottish winter. To the wonder of their enemies they kept going, repeating their unexpected victories. Summer came again and the decisive battle of Kilsyth was fought. Even now, Montrose had surprises for his enemies. The summer of 1645 was hot, and the enemy watched indignantly as the Highlanders stripped off their upper clothing and then charged on them. Montrose had ordered that

. . . all his men, both horse and foot, to throw off their upper clothes and fight stripped to their

shirts; which they cheerfully and readily obeyed and stood prepared for the attack, being resolved either to conquer or die. (*Memorials of James Graham*)

After this victory the two largest towns of Edinburgh and Glasgow surrendered. The city of Edinburgh, already stricken by the plague, opened its gates to him fearfully. The citizens had not treated their prisoners well and they expected to be plundered without mercy in return. The city delegates were "admitted to an audience, they made free surrender to him of the town . . . and implored his pardon".

They did not need to ask. Montrose was generous in victory. In spite of the fact that one of his sons had died on the winter march, the other was a kidnap victim and his friends had been kept in appalling conditions, Montrose freely forgave them. His kindness was not to be repaid, for many of them were soon to betray him to the Covenanters. The battle for Scotland was not yet over and defeat loomed for Montrose. The newly appointed General David Leslie and his Covenanting army of Scots swept back from England. Many of Montrose's men had left for home and his depleted forces were defeated at Philiphaugh in September. They fought valiantly but were hopelessly outnumbered, and at last Montrose was forced away from the battlefield by his friends. The Royal Standard, which meant so much to them, was saved by an Irish soldier who,

. . . seeing the enemy masters of the field stripped it [The Standard] from the shaft and wrapped it round his body; and, without any other clothes forced his way, sword in hand, through the enemy and brought it to Montrose. (*Memorials of James Graham*)

After this defeat Montrose did not give up. By the Spring of 1646 he had rounded up another army and was prepared for new action. This time, events in England ended his plans. The King had surrendered to the Scots Covenanters in England and had taken the decision that his future would be safer with them. He told Montrose to disarm. Montrose knew, yet again, that the King was wrong but

**20** In this tragic scene Montrose is carried through the streets of Edinburgh to his execution. He had kept his dignity and courage throughout his imprisonment. The people who came to jeer were apparently moved to tears by his noble bearing. From a window the Earl of Argyll watches his enemy's progress to his death with satisfaction.

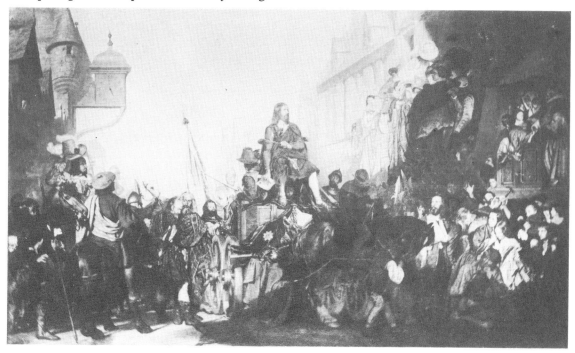

he could not convince him. Charles wrote to him:

You must disband your army and go into France, where you shall receive my further directions. This may at first startle you; but I assure you that if, for the present, I should offer to do more for you, I could not do so much.

Charles had cast himself into the hands of his enemies and Montrose knew it. Miserably, he prepared to leave the country for the sake of his own life, but he did not forget his loyal friends. He wrote to Charles begging for the safety of all those in Scotland who had served the King and whose lives were now in danger:

Only I humbly beg Your Majesty to be pleased to consider that there are nothing remembered concerning the immunity of those who have been upon your service; that all deeds in their prejudice be reduced: and those of them who stay at home enjoy their lives and property without being questioned; for such that go abroad that they have all freedom of transport; as also that all prisoners be released.

After much difficulty Montrose arrived in Bergen. Even in Europe he was able to distinguish himself; he become a Marshal of France and a Marshal of the Holy Roman Empire. Meanwhile in England the actions of the next four years proved Montrose to be right. The Scots Covenanters handed Charles over to Parliament and he became a prisoner. When the news of the King's execution in 1649 reached Montrose he collapsed from shock. When he recovered he declared his loyalty to the future Charles II and in 1650 he returned to Scotland to fight for him. There was now a price on his head and, after being defeated at Carbisdale he was betrayed to his enemies. McLeod of Assynt promised to help him escape but secretly told his enemies where to find him. Montrose was kept in an undignified and uncomfortable captivity until he was brought to Edinburgh to die. Montrose was hanged and his body cut into pieces, which were sent to the four principal cities of Scotland. There is no doubt that many Scots

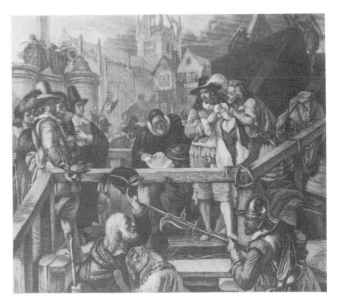

**21** "The Marquis of Montrose at the Place of Execution". Montrose receives comfort from his loyal supporters while the executioners wait in the background. In his hand he holds his chaplain's biography of him, which was hung round his neck at his execution. At the bottom of the picture the simple tartan-clad Highlanders who loved and supported him are held off by the guard. Although Charles II was now dependent on his father's former enemies, the Scots' Covenanters, he never really trusted them and they were to suffer for their former disloyalty when he regained his English throne in 1660.

thought him a traitor for leaving the cause of the Covenant and joining the King, but even his enemies could not deny that he was brave. This description of his execution by his Chaplain, George Wishart, indicates that he certainly died in the same stylish and courageous way he had lived:

He went up to the top of that most prodigious gibbet, where having freely pardoned the executioner, he gave him three or four pieces of gold and enquired how long he should hang there; he told him three hours. Then commanding him at the uplifting of his hands to tumble him over, he was accordingly thrust off by the weeping executioner. The whole people gave a general groan and it was observable that even those who, at his first appearance had bitterly inveighed against him, could not now abstain from tears. (*Memorials of James Graham*)

# Sir Humphrey Mildmay (1592-1665)

During the war there were many people who managed to remain uninvolved in the fighting while living in the middle of a "fighting area". Sir Humphrey Mildmay was one of these people, who may be called observers of the action. He was a rich man, owning a house in London at Clerkenwell and two fine country houses in Essex and Somerset. He was a member of a great Puritan family but he did not share his family's religious views. On the contrary, he hated Puritanism. His grandfather had served Queen Elizabeth as Chancellor of the Exchequer and his brother, Sir Henry, was the Keeper of the Jewel House.

When war broke out members of the family took different sides, but not because they felt strongly about the cause. Parliament held London and so Sir Henry became a Parliamentarian because it was in his own interests, while Sir Humphrey's younger brother, Arthur, supported one side then the other as it suited him. Sir Humphrey himself supported the King, but not to the point of fighting for him.

Sir Humphrey kept a diary from 1633 to 1652, which covered all the years of the war. He was not at all a political man but he liked to observe events and he had been to Westminster on most days during the 11 years of the King's personal rule (when no Parliament had been called).

In 1640 Sir Humphrey went to see the

**23** The elegance which traditionally characterizes the Royalists is depicted in this contemporary ballroom scene. The rich decorations of the room and the profusion of lace and feathers on the people shows them at their grandest.

**22** Sherborne Castle, owned by, the Royalist Digby family. It came under fire during the war because it was used for recruitment by the Royalists. The Earl of Hertford was in residence when it was attacked but he escaped to lead the King's forces in the South West. Lord Digby himself was one of the King's chief officers.

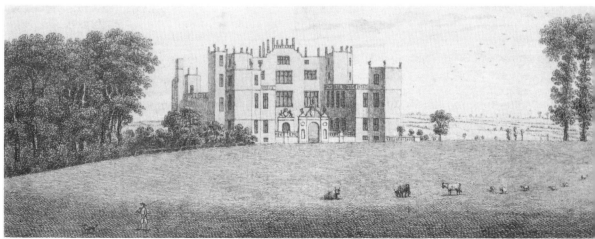

famous Long Parliament take their seats. Sir Humphrey disliked them as he did all people with Puritan ways. He was a man who enjoyed the pleasures of life and he did not appreciate the Puritan love of simplicity. He was appalled to find his own sister following Puritan customs. On Fridays it was customary to serve a meatless meal but the Puritans thought this was a "Papist" habit, so he was disgusted to find that instead of fish she served him "a dinner of flesh like a Puritan". He even called a poor-quality horse he had acquired a "Puritan horse".

In those Puritan days Sunday was very special. Sport was discouraged and attendance at church was thought to be absolutely necessary. Sir Humphrey loved to ignore all this restraint and on Palm Sunday 1640 he wrote gleefully in his diary: "My wife went to Church and I remained at home till four and then to see the wrestling."

When the war broke out his country estates were in danger of being attacked from soldiers of both sides. His Essex home, Danbury Place, was in particular danger, being at the centre of some of the most important political tension of the war. He records in his diary:

To Chelmsford in a coach to see the foolery and impiety of the Earl of Warwick and his rabble.

His Essex home was under threat from soldiers of both sides, who took what they could from the country through which they passed:

News of the devils abroad a-plundering, at home all day expecting the plunderers but am safe as yet.

In spite of the war, and in the middle of all the chaos, Sir Humphrey managed to slip in and out of London. He could not live there in quite the same ease and luxury as he enjoyed before the fighting. He packed up his most valuable possessions at his home in Clerkenwell and sent them to Essex, where he hoped they might be safe. However, in April 1643, he found that his Essex home had been plundered:

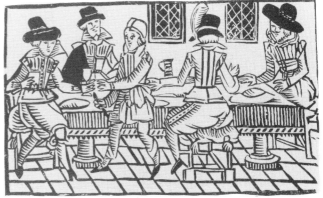

24 Royalists enjoy a meal together in this early seventeenth-century print from the Roxburgh Collection. The restrictions of the Puritans on eating and drinking were treated with derision by the Royalists.

God help and deliver us from these troubles and traitors, late in bed to dinner and then I went forth towards night. I was forced to come away to hide.

There were many changes in the religious life of the country, especially in London. One of the most unpleasant to Sir Humphrey were the frequent fasts, which he took delight in ignoring whenever he could. The great Parliamentarian, Sir John Pym, and the other Puritan M.Ps had ordered many days to be kept as strict fast days, and on one of them, on 21 July 1643, Sir Humphrey noted: "This day Mr Pym kept fast. I dined with Sir John at the "Cocks" and supped at home."

As the war moved on, Parliament became stricter, especially in the movement of citizens in and out of London. It was necessary to have a pass to leave the city. Sir Humphrey wanted to go to Somerset but it took him three months to obtain his pass. As he travelled towards Somerset he met the Queen and her company on their way to Exeter. He was happy to escort her on part of her journey, and then, presumably feeling he had done his duty, he hastened on to what he thought would be safety in Somerset. But in June 1644 he had to report that "at night came the rout and plundered my sword and bridles".

Although Sir Humphrey himself was not involved in the fighting he was constantly in fear of being caught up in it and his diary records that he was often only one step ahead of the armies. In 1645 he reported (obviously

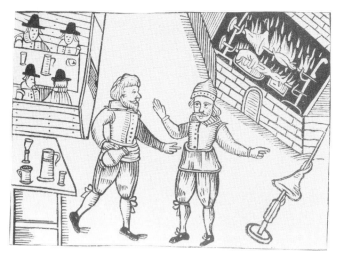

**25** Nick Froth the tapster and Rulerost the cook complain about the Sabbath Day restrictions on their trade. In 1641 the Puritan Long Parliament issued a prohibition on all feasting, merry-making and the opening of taverns on a Sunday.

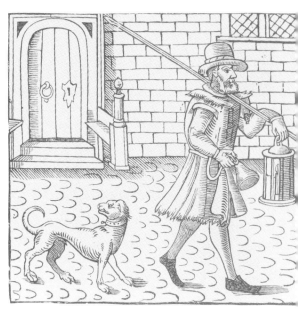

**26** The bellman was a typical sight throughout seventeenth-century London. He would tell the time regularly and comment on the weather and anything else of importance. Pepys wrote in his diary: "I staid up till the bellman came by with his bell just under my window, as I was writing this very line, and cried, 'past one of the clock and a cold, frosty windy morning'."

in haste): "To Bristol with all my crew in flight by night".

His other home, Queen Camel in Somerset, was plundered and he had all the worry of knowing that his son, Nompee, eldest of his 15 children, was a soldier. In October 1644 he recorded: "this day poor Nompee was wounded". Fortunately Nompee's wounds (sustained at the Second Battle of Newbury) were not fatal but in the siege of Colchester he was taken prisoner, where he was probably handed over to his own kinsman, Carew Hervey Mildmay, who commanded a Parliamentary regiment.

When the war ended, Sir Humphrey, along with many other Royalists, found his estates under threat. In 1646 he was commanded to appear before a Parliamentary committee. It was necessary to find influential friends but it was difficult for a defeated Royalist to find people willing to speak for him. Even his Parliamentary brother was not of much help:

I rose early and marched to my brother Henry and was attending him at Westminster all the day to small proof [with little reward]. Home to dinner and not well pleased with my fortunes.

Eventually Sir Humphrey managed to borrow money and paid the fine that was levied on him. He lived to see the restoration of Charles II, and died in 1665 at the age of 74.

# Sir John Marley (1590-1673)

Oh, what a brave knight was Governor Marley!
Stout Sir John Marley!
Who fought late and early;

Though the garrison lived and fed rather barely.
(Newcastle poem, quoted in Richard Welford,
*Men of Mark Twixt Tyne and Tweed*, 1895)

Sir John Marley, the hero of Newcastle-Upon-Tyne, was the son of a coal merchant and rose to become mayor and governor of the city. He was also Governor of the Hostmen's Company, which made him an important man in the coal trade.

Coal from Newcastle was vital to London because the collier ships brought essential heat to the city. Newcastle was indeed "the town that warmed the nation's heart". Even before the Civil War, when the Scots had marched into England to press recognition of their National Covenant on the King, it was realized that Newcastle's defences were crucial and must be strengthened. John Marley took an active part in this work and received his knighthood as a reward from the King himself in 1639.

The King's agreement with the Scots failed and in 1640 they occupied Newcastle, intending to put pressure on the Government by holding up coal. The Treaty of Ripon removed the Scots but not their Puritan sympathizers living in Newcastle. They saw the renewed fortifications with alarm and wrote of their fears to Parliament in 1641;

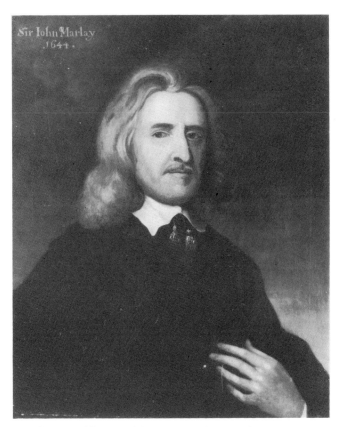

**27** Portrait of Sir John Marley, 1644, by an unknown artist.

We fear a storm and see it already begun. The Earl of Newcastle came here Friday last . . . 300 soldiers sent down to Tynemouth Castle to guard it, and they all have arms given them out of the Magazine here in this town. There are great guns going down to them, six pieces. They are casting up trenches as fast as may be. . . . We never lived in the like fear which we now live in. . . . They have got engineers out of Germany and gunners for the great guns. There is here an expectation of some directions from Parliament to countermand them; and if speedy course were yet taken, it might reduce all that is done. (*Journals of the House of Lords*)

Parliament could do little to help the worried Puritans. They petitioned the King to remove his forces from Newcastle and its environs but, naturally, he refused. Two ships were sent from Parliament to observe and direct but they were ignored. Sir John and his fellow townsmen contined to build up Newcastle's defences for the King and broke off all contact with Parliament, who soon admitted that "the whole trade of Newcastle for coal or otherwise will be subject to be interrupted whensoever His Majesty shall please".

**28** Below this picture of the Tower of London the coal barges can be seen coming up the Thames. The coal was shipped from Newcastle-Upon-Tyne and other coal towns of the North of England. It was vital for the capital's domestic and industrial use and its price and supply were therefore of keen interest to the citizens of London, especially during the war.

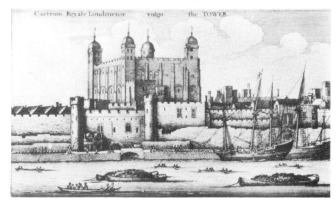

When war was finally declared in 1642 Sir John Marley felt himself prepared to defend the city for the King. Money, horses and ammunition poured in from Holland and for the first two years of the war the town held firm. In 1642 Parliament issued an ordinance which declared its intention of taking this vital town.

No ships or barks shall henceforward make any voyage for the fetching of coals or salt from Newcastle, Sunderland or Blythe or carrying corn or any other provision of victual until that town of Newcastle shall be freed of and from the forces there now raised and maintained against the Parliament. (*Calendar of State Papers*, 1642)

When Parliament signed the Solemn League and Covenant with the Scots in 1643 they had at last an opportunity to take this northern stronghold from the King's control. On 19 January 1644 a Scottish army under the command of Alexander Leslie, Earl of Leven, crossed the border into England. The Royalist army retreated as they approached. Newcastle had been occupied with ease in 1640 so Leven expected no trouble. He was amazed to find that Newcastle was ready for a siege. He first marched south to help win the decisive Battle of Marston Moor, where many Northumbrians fell, and then, in the autumn, returned north to take Newcastle. His great army faced a force of only 1700 men; 800 of the trained band and 900 ordinary people: "volunteers, pressed-men, colliers, keilmen and poor tradesmen". The Earl and his army made camp and sent a courteous letter to Sir John:

To the Right Worshipful, the Mayor the Aldermen and Common Council and other inhabitants of Newcastle. Right Worshipful and Loving Friends our appearance here in this posture . . . may occasion strange thoughts in you . . . if you yield to this motion you shall find us ready to do our part.

Sir John sent an equally courteous reply but refused to surrender. He and Leven carried on a long correspondence but Sir John's intention

of holding out was quite clear. Meanwhile, the Scots began to dig mines under the castle. The tunnels were filled with gunpowder, ready to be fired and so breach the walls. The town had no supplies and the people were hungry. Pamphlets were tossed over the walls by the Scots urging the poor and frightened citizens to surrender. They read: ". . . it is no more wisdom nor honour but extreme madness any longer to hold out".

The Scots bombarded the castle in preparation for a final attack and still the negotiations dragged on, with no result. Sir John was playing for time, perhaps hoping for relief from his own side. Leven was growing increasingly impatient with him. Eventually, after almost 10 weeks, commissioners were allowed in to negotiate, but an observer noted indignantly that

. . . the Scottish commissioners finding themselves deluded and delayed by the Governor, who was void of all candour [lacking all truth] and tyrannised so absolutely over the

**29** Seal of the Fraternity of Coal Traders of Newcastle Upon Tyne. This group of merchants, the Ostmen or Hostmen, had control over the loading or unloading coal on the Tyne. They established the price of coal shipped around the country and were therefore a very powerful organization.

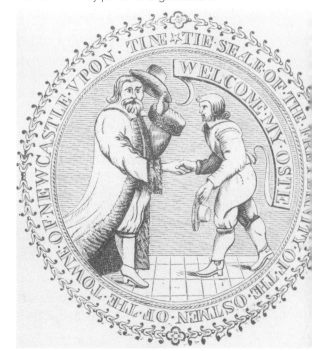

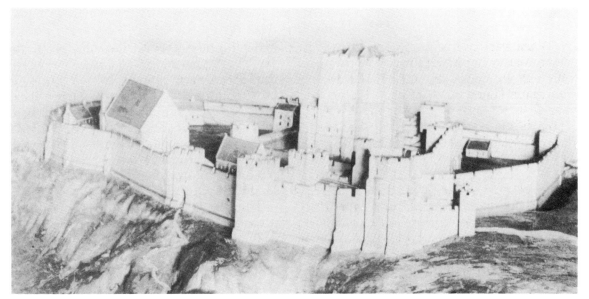

**30** This model of Newcastle Castle as it was in the fourteenth century was made by John Ventress in Victorian times. Today only the keep of the castle and part of the walls may be seen.

minds and fortunes of the people that none durst express their inclinations to peace and happiness . . . he advanced so far in his own conceit [vanity] that he thought the army would have taken a sum of money and been gone. . .

Threats to destroy the Steeple of St Nicholas received an answer from Sir John that his Scots prisoners would be in it and Leven would "bathe his hands in the blood of his countrymen, who were placed there on purpose either to preserve it from ruin, or to die along with it". Leven had come to the end of his patience. He sent a demand for an immediate surrender, offering free passes to any who wanted to leave and no plunder and, he added, "You are likewise earnestly desired by no means to conceal this, our last offer and warning from the citizens and soldiers. . . . If in these things you fail, you may expect the extremities of war." Sir John tried to delay and replied: "If you would shun effusion of blood, as you profess, forebare your acts of hostility until we give you an answer on Monday."

Sir John's last letter on 19 October was extremely rude:

My Lord – I have received diverse letters and warrants subscribed [signed] by the name of Leven, but of late can hear of none that have seen such a man; therefore, to remove all scruples, I desire our drummer may deliver one letter to himself. Thus, wishing you could think of some other course to compose the differences of these sad and distracted kingdoms than by battering Newcastle, and annoying us who never wronged any of you; for if you seriously consider, you will find that these courses will aggravate, and not moderate distempers. But I will refer all to your own consciences, and rest, your friend,

John Marley.

The next morning, 20 October, the attack began. The mines were sprung and breaches made in the walls. The battle was violent and bloody. William Lithgow, a Puritan Scot with Leven's army, wrote an account of the battle, which was published in 1645:

The thundering cannon roaring from our batteries without and theirs rebounding from the castle within; the thousands of musket balls flying at other's faces, like to the driving hailstones . . . the clangour and carving of naked and unsheathed swords, the pushing of brangling pikes crying for blood and the pitiful clamour of heart-fainting women imploring mercy for their husbands, themselves and their children.

Sir John and the other officers fled to the castle, where they locked themselves in.

Meanwhile the townspeople outside surrendered. They were weak through hunger and had no energy left to fight on against impossible odds.

They presently called for quarter and laying down their arms without assurance, some were taken, some were shaken, some stood still and some fled away to hide their bleeding bodies in some secret shelter. Yes, some sat down by their father's fireside as though they had carried no arms. (William Lithgow, *A Survey of Newcastle Upon Tyne*)

The victorious army began the 24-hour plunder which was their right, but William Lithgow records there was little to be had "excepting only household stuff, as bed clothes, linen, tanned leather, calf skins, women's apparel, pans, pots plates and such like". They found the people to be extremely poor and so short of food "that it was considered that unless one half of the people devoured the other they could not have held out ten days longer".

William Lithgow believed all this to be the fault of the still-obstinate Sir John Marley. He accused him of concealing Lord Leven's reasonable terms from the people. Sir John, still in the castle, was certainly afraid of the angry mob of his own citizens outside. He tried to negotiate his surrender, but the Earl of Leven furiously refused all terms. After four days of great hardship Sir John and his fellows surrendered unconditionally and Sir John "was committed to his house by a strong guard to defend him from the fury of the incensed people, for he is hated and abhorred of all and brought many families to ruin". From this house he was removed to the castle dungeon and it looked as though he was doomed to die. The Houses of Parliament both decided to "except Sir John Marley from all mercy and pardon and do therefore direct that he may be proceeded with according to the course of war".

Sir John was ordered to London but he was lucky enought to escape his gaolers and he fled to the Continent, where he was joined by his family. He remained abroad for 12 years and then rather ungraciously offered his services to the new republic. They were suspicious of him, some believing him to be a Royalist spy. He returned to Newcastle, now an old man, and when the King was restored he regained all his former privileges. He even became Member of Parliament for Newcastle in 1661 and remained the town's representative until his death in 1673. The town itself was given an honourable motto by the Stuarts in memory of its brave struggle on their behalf: "*Fortiter Defendit Triumphans* ("triumphing by a brave defence").

# FOR THE CAUSE OF PARLIAMENT

We stood upon our liberties for the King's sake, lest he might be the king of mean subjects or we the subjects of a mean king. (Sir Ralph Verney quoted in Frances Parthenope, Lady Verney, *Memoirs of The Verney Family*)

Sir Ralph Verney's comment shows clearly the opinion of those who took up Parliament's cause for idealistic reasons. They truly believed themselves to be fighting for the King who, they said, had been led astray by "evil counsellors". One of their battle cries was "For King and Parliament". Their motto was "God with us", which explains the strong power of religion in the Good Old Cause, as Parliament's aim came to be called. To a Puritan, God came first, even before loyalty to the King. It was felt that Charles I, influenced by his Roman Catholic wife and his advisers, was bent on removing the religious liberties of the Church of England. Proof of this was seen in the Arminian Church reforms of Archbishop William Laud in the years before the war. All this was closely linked with the precious idea of Parliamentary freedom, which, to his opponents, Charles had threatened.

Parliament's more committed supporters did not take up the cause lightly. It was a matter for deep consideration and prayer. After all, it went against every Englishman's love and duty to the Crown to take up arms against the monarch himself. In *The Life of Colonel John Hutchinson* Mrs Lucy Hutchinson speaks of her husband spending long hours in study and prayer and at last finding himself. "abundantly informed in conscience of the righteousness of Parliament's cause in point of civil rights". And John Hodgson, on joining Parliament's army, wrote: "I did not do so rashly, but had many an hour and night to seek God and know my way." (*Autobiography of Captain John Hodgson*)

This did not mean that all Parliament's supporters were strict and sober Puritans, and the nickname "Roundhead", with its suggestion of severity in closely cropped hair, was often misapplied. John Hutchinson, his wife reports, had a fine head of hair – so did many others. At the other end of the social scale Nehemiah Wharton was an odd mixture of a sober Puritan, who could sit through to the end of a Church service while wanted for battle one day and the next enjoy a jolly feast of poached meat.

Parliament's supporters were drawn from all classes of Puritans in the towns and from the yeomen of the countryside. They enjoyed the support of most of London and were not without aristocratic backing either. Several of their generals were noblemen, in particular their Commander in Chief, the Earl of Essex.

Again, as with the King's side, there were many who fought reluctantly. Parliamentary General Waller wrote to his Royalist opponent, Sir Ralph Hopton:

Great God, who is the searcher of my heart, knows with what a perfect hate I detest a war without enemy. . . . We are both upon the stage and must play the parts that are assigned to us in this tragedy, but let us do it in the way of honour, without personal animosity.

The same ambitions of personal jealousy and greed, which influenced some of the King's supporters motivated many of those on Parliament's side too. The army could be a good way to make a profit. A Parliamentary soldier wrote:

Our regiments discovered their base ends and demanded five shilling a man. There is much dissension between our troopers and foot companies. The footmen are much abused and sometimes pillaged and wounded.

Parliament was not without its own inspiring leaders either. Pym's brilliant speeches roused the City of London and Sir Thomas Fairfax's honest gallantry swayed many waverers. As the war progressed, death and destruction hardened people's feelings, and a visit from a hungry army on either side could influence opinion against them.

The later years of the war found a more resolute spirit among Parliamentarians. It became clear that decisive victory was the only possible goal and this change of mood was seen in the Self-Denying Ordinance of 1643 and the formation of the New Model Army. Although this new spirit led to some defections from Parliament's side it was to be a winning formula in the end.

# John Pym (1584-1643)

I neither directly or indirectly ever had a thought tending to the least disobedience or disloyalty to His Majesty, whom I acknowledge my lawful King and Sovereign and would expend my blood as soon in his service as any subject he hath.

So wrote John Pym in his "Declaration and Vindication" published in 1643, just before he died. Charles I certainly took a very different view of Pym's life and intentions. It was certainly due to "King Pym", as he was called, that Parliament was organized and held together in those early and confused years of the war.

John Pym was born at Brymore in Somerset of a wealthy family and studied law at Broadgates Hall (now Pembroke College), Oxford and at the Inns of Court. He first entered Parliament in 1614 and soon acquired a reputation for hard work. His wife, Anna, died in 1620, leaving him two sons and three daughters, and from then onwards he dedicated his whole life to politics. Dr Stephen Marshall, a clergyman who knew and admired him, wrote:

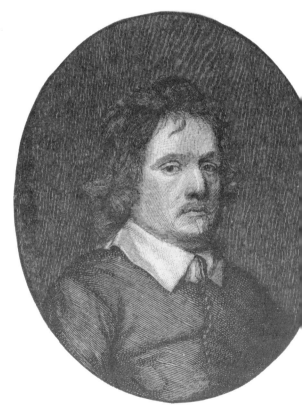

**31** Portrait of John Pym by Samuel Cooper.

What he was from that moment was only for the public good; in and for this he lived and by this

34

he died. It was his meat and drink, his exercise his recreation, his pleasure, his ambition, his all.

Pym was a religious man, a convinced Puritan who believed that Parliament's fight was for God and the true laws of England. In his "Declaration and Vindication" he wrote:

My zeal to religion and God's cause which I perceived to be trampled underfoot by the too extended authority of the prelates [bishops], who, according to the purity of their institutions, should have been men of upright hearts and humble minds, shearing their flocks and not flaying them.

Pym was not a popular man and he did not care to be a favourite with anyone. Even before the war he suffered imprisonment on three occasions for his opposition to the policies of James I and Charles I. Pym felt that the ancient laws of England, including the rights of Parliament, were being abused by the Stuart kings. In a famous two-hour speech in April 1640 he put forward the cause of Parliament. He assured his listeners that he was loyal to the King but that it was necessary to fight him to preserve the nation's rights:

We the Lords and Commons in Parliament assembled having taken into serious consideration the present state and condition of imminent danger in which the Kingdom now stands by relations of a malignant party prevailing with His Majesty; putting upon him violent and perilous ways and now in arms against us for the oppression of the True Religion, the Laws and Liberties of this Kingdom, and the Power and Privilege of Parliament; all which every honest man is bound to defend . . . therefore we finding ourselves engaged in a necessity to take up arms likewise for the defence of these, which must otherwise suffer and perish.

Not surprisingly, Pym was one of the five Members of Parliament sought by Charles I after the Grand Remonstrance. Parliament protected him and he returned in triumph to be their leader. He was a compelling speaker

and his Protestation was heard with great eagerness. Copies were sent around the country. Pym was convinced that his cause was right and the King's actions were wrong:

If the King by the right of a conqueror gives laws to his people, shall not the people by the same reason be restored to the rights of the conquered to recover their liberty if they can?

Pym held the law above anything else. To him it was God's law and nothing must damage it. He said:

**32** King Charles I opening Parliament. A scene which is still repeated today. Charles sits on a raised throne while the Members of both houses sit and stand below. Members sat on both sides as there was no separate Opposition party as we know it today.

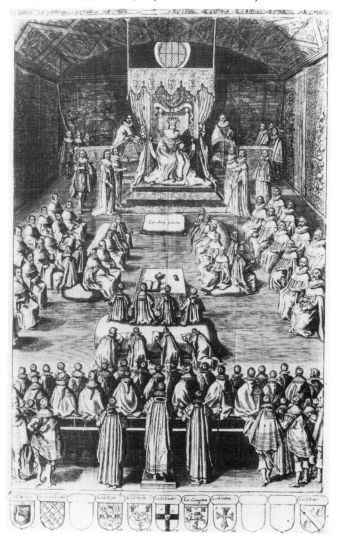

The law is that which puts a difference betwixt good and evil, betwixt just and unjust. If you take away the law, all things will fall into a confusion. Every man will become a law to himself.

When the King left London in January 1643 Pym set to work to persuade the Lords to join with the Commons in fighting for the country's freedom. When the King tried to take possession of Hull and the Queen was selling the Crown Jewels abroad, Pym thundered:

By the known law of the kingdom, the very jewels of the Crown are not the King's proper goods but are only entrusted to him . . . as the towns, forts, treasures, magazines, offices and people of the kingdom itself are entrusted unto him for the very good and safety and best advantage thereof and as this trust is for the use of the kingdom so it ought to be managed by the advice of the Houses of Parliament, whom the kingdom hath entrusted for that purpose. (Speech to the Commons, 1643)

While still assuring Charles that his Parliament was loyal Pym gained control of the fleet. When many of his friends in Parliament began their double duties as Members of the House and as soldiers Pym

**33** Westminster at the time of Charles I. Westminster Hall is still standing but the Parliament house has been rebuilt and many other buildings, including Big Ben, have been added over the years.

devoted himself to holding Parliament together. To oppose the King was a terrifying prospect which many could not face, but Pym told them they were right because,

It appears that the King, seduced by wicked counsel, intends to make war against the Parliament, who in their consultation and actions have proposed no other end unto themselves but the care of his kingdoms and the performance of all duty and loyalty to his person. (Speech to the Commons)

The Committee of Safety was set up, in which Pym was the prime mover. He knew that wars were not won without organization and money, and he proved skilful in raising money for the cause, and the chief administration of Parliament's efforts was on his shoulders. Dr Marshall noted that, "from three of the clock in the morning to the evening and from evening until midnight he laboured in the service of the commonwealth."

Pym hurried between Hampden and Essex on the battlefield and the citizens of London. He still hoped that the King might see the error of his ways, especially after the bloodshed of the first Battle of Edgehill, but it was not to be, and Pym said sorrowfully: "Though we desire peace very much, yet a peace to betray religion or betray our liberties we shall always esteem worse than war."

Pym needed all his energies in his last two years of life. The King appeared to have all the

Ciuitatis Westmonasteriensis pars.

Parliament House     the Hall     the Abby

advantages. He wrote to the city of London demanding their surrender and offering a pardon to all except Pym and his associates. The King's demands were read to a silent audience. Pym stood firm, replying that Parliament and the city would stand together. His reply was followed by tumultuous applause and the people set up a chant: "We will live and die with them! We will live and die with them!"

In spite of all this bravery the King was still having great success in battle, and fears were spreading through London like a disease. Pym left nothing to chance. He told of a plot for the overthrow of the city. Everyone was warned to be on their guard against plotters, who would enter the city pretending to be peacemakers. Meanwhile, Pym was able to set up an elaborate spy network. It certainly helped to take the people's minds off the hardships of war for a time.

In the background Pym was working to secure a winning alliance for Parliament with the Scots. In common with many others on his side he despaired at the lack of resolution shown by their Commander-in-Chief, the Earl of Essex. It was well known that Essex wanted to come to an agreement with the King. Pym visited him, begging him to be strong. All this affected the people, who were short of food and worried about what would happen to them if the King won. Riots broke out in London and a group of women blocked the door of the Commons shouting: "Give us the traitor Pym that we may tear him in pieces! Give us the dog Pym."

Pym was dying. He had a tumour which gave him great pain but he struggled on in spite of frequent fainting fits. A gloating Royalist wrote from Oxford: "from London we hear that Pym is crawling to his grave as fast as he can." Pym lived to see the Solemn League and Covenant signed with the Scots in September 1643 but he did not see the Covenanting Army enter England. In the house of the Royalist Lord Derby, which had been requisitioned for the war, Pym died. It was 8 December 1643. The next year was to see a great reversal of Parliament's fortunes but the man whose hard work had done so much to bring it about was dead. He was buried with great honour at Westminster, but the Royalists lit bonfires and celebrated at Oxford. Such was the hatred felt for this man that 17 years later his remains were dug up and tipped into a pit by the common hangman.

# Sir Thomas Fairfax (1612-71)

Sir Thomas Fairfax was one of the greatest Parliamentary generals of the war. He was also an intelligent, kind and thoughtful man. He cared for the soldiers under his command and did much to try and improve their pay and conditions. The life of a soldier in this war was unpleasant and he was often as much in danger from his living conditions as from an enemy bullet or sword. Here was one officer who understood all this and who inspired great affection among those who served him. One of the army Chaplains wrote to him;

One of the greatest comforts I have had in this world, next to the Grace of God in Christ, to my poor soul hath been to be a member of your army. . . . For myself I am resolved to live and die in your and the kingdom's service.

Sir Thomas Fairfax was born in Denton in Yorkshire, the son of Ferdinando, Lord Fairfax, another great politician of the time. Thomas was educated at St John's College, Cambridge, and from an early age he was interested in a career in the army. When the

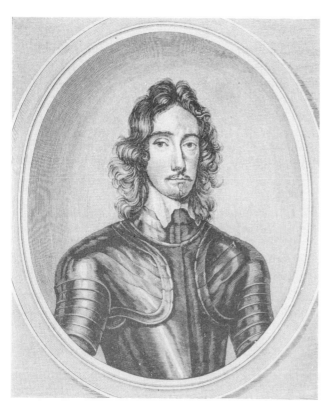

**34** Portrait of Sir Thomas Fairfax.

Civil War broke out he was already an experienced soldier, having seen action in France and the Low Countries. He quickly emerged as one of Parliament's most able generals, and although he was only 30 years old in 1642 he could already inspire respect.

Sir Thomas was entrusted with the command of some of Parliament's most important campaigns. He quickly acquired a reputation for courtesy and justice. Soldiers, even great generals, were not usually noted for their thoughtfulness, but Sir Thomas Fairfax was one of the exceptions. Early in the war a gentleman wrote to Sir Thomas begging protection for one of his relations:

There is a lady, My Lady Casselton, a kinswoman of mine, who hath been frightened by some of your troops that have plundered her house. . . . She is a lady and I know you are civil to all, much more [especially] to Ladies.

Even at the end of the war, when he was tired and ill, Sir Thomas did not forget to be kind to the elderly Marquis of Worcester who was under siege in Ragland Castle, one of the last pockets of Royalist resistance. The old Earl had spent a lot of money on the King's behalf and he would not now give up his "poor cottage", as he called it. He stocked it up with food, soldiers and ammunition and prepared to sit it out. Sir Thomas wrote to London:

I have offered the soldiers honourable conditions and that the Earl should remain quiet in his house until the Parliament be pleased to dispose otherwise of him.

It was not long before the poor old Marquis surrendered and was soon sitting down to dinner with Sir Thomas himself, who then allowed him to retire in peace to Bath.

In the early years of the war the Parliamentarians could not command as much ready money as the Royalists. Their armies expected that the areas through which they moved would support them, but this did not always happen. More often, the local people did not want the soldiers and, anyway, they did not always have enough provisions to feed themselves, let alone several thousand newcomers. 1643 found Sir Thomas in Yorkshire, with instructions to capture the clothing towns of Leeds and Wakefield, but the people who should have fed them were poor. Sir Thomas wrote to his father who, he hoped, might be able to help:

The people in these clothing towns are not able to subsist. . . . I thought it fit to acquaint you with it . . . therefore humbly desire Your Lordship not to defer this business, but if no aid can come to us, then to give us advice and order what to do, for long this country cannot subsist.

Stealing was the usual answer for hungry soldiers, but Sir Thomas knew that such action could only lead to misery and unpopularity, which would damage the cause in the long run. In spite of his difficulties Sir Thomas had managed to capture Leeds by the end of January 1643 and, thankfully, he had been able to save the people from his own men;

I found when I came great numbers of people in the town, who by Captain Winge's good government and care, whom I had sent thither to the town, kept them from doing much hurt by pillaging.

Poverty was a major problem even among the officers. They had been used to comfortable living in their own homes before the war and the cold December weather found them in the inhospitable north of England. A group of Sir Thomas's officers wrote him a combined letter of complaint and a request to be able to help themselves to what they needed:

Conceive of us as men who have lived in a reasonable affluence of all our conveniences. . . . If these countries [the north of England], for whom by God's Providence we have done great things, be unwilling to supply us, that we may be enabled to provide clothes for our backs, shoes and other accoutrements [items] for our horses and some comfortable refreshing for our bodies. . . that some speedy and effectual course be taken to compel them.

Sir Thomas wrote to the Parliamentary committee, who were running the war for Parliament, asking for help. They had none to give and, to make matters worse, his men were ordered to the siege of Nantwich. Ragged and miserable, the army prepared to set out, but Sir Thomas did not give up. Resolutely, he wrote again;

Though many objections arise from the present condition of the forces under my command. . . I resolve if God permit to begin my march within 2 days and would have done so sooner had not the necessary provision of clothes and other things for my men retarded my resolution somewhat.

On this, and many other occasions, Sir Thomas had fed and clothed his men out of his own pocket.

Poverty was not the only problem for Sir Thomas. There was poor organization in these confused early years of the war. Many Parliamentarians were half-hearted about the whole war effort and did not want "to beat the King too much". This led to disagreements and even desertions.

Although Sir Thomas continued to have great success in military encounters, the pressures from problems with his men were becoming an enormous worry to him. Wearily, he wrote to his father:

I have endured some hardship since I parted with you, being forced to march and watch night and day in this frost and snowy weather. I have had much trouble to command these forces I now have, there being such divisions among the commanders which doth much impair my health.

When he was appointed general of all the northern forces Sir Thomas was inundated with letters of complaint. Colonel Duckenfield, Governor of Chester, wrote of the ingratitude of the local people;

Most of them [the soldiers] have been upon service very long without any pay: and the gentlemen of the country take care to keep our men upon continual hard duty; but they regard not the poor soldiers when the danger is passed. . . . I shall be willing to do duty as a common soldier myself rather than to command men in this way.

Sir Thomas himself was growing increasingly irritated with the poverty and lack of co-ordination in Parliament's army. As a soldier who was permanently in the field he could see the need for a concerted attack on the King and that this could only be done with a properly fed, trained and equipped army. He was not alone in his dream of a new type of army for Parliament. In company with Oliver Cromwell he could see what Parliament could only end this war successfully with an efficient force who really wanted to win. Oliver Cromwell had already shown what such a body of men could do with his special regiment (nicknamed "The Ironsides" by their enemy, Prince Rupert) which had joined with Fairfax to defeat the Cavaliers in the

largest and bloodiest battle of the war at Marston Moor in July 1644. Sir Thomas' dream was fulfilled when 22,000 men were allocated to his command. This was the New Model Army. It could move anywhere in the country and as it was equipped and trained with money from Parliament it need not be dependent on local areas for its supplies. Sir Thomas was free to nominate all the officers and, together with Oliver Cromwell, began training this new army.

By the summer of 1645 it was more than a match for the King's successful nephew, Prince Rupert. On 14 June the New Model Army had its greatest victory, at Naseby. In his *History of the Rebellion* the Earl of Clarendon wrote: "The King and the Kingdom were lost at Naseby."

This was certainly the decisive battle of the war, but there was still work to do. Sir Thomas marched off to the South-West, breaking down all Royalist resistance as he went. There were great dangers to be met, as he wrote to his father from Credition in Devon:

The other day we sent a party over the River Ex to possess Poldram House: but, being possessed by the enemy and the party not sufficient to storm it, our men took a church half a mile nearer Exeter from whence the enemy sallied out that night with 500 musketeers and assaulted our men in the church. They disputed the matter for three hours very hotly: the enemy came up close to the windows with halberts, and threw in about fifteen grenades, but by the goodness of God, our men forced them to retreat, leaving two men slain and many others wounded. We, finding the place more dangerous than useful, quit it again.

In spite of all these dangers Sir Thomas was able to write to his father by the Spring of 1646 that,

Through God's goodness we have almost put a period [end] to the western war, there remaining now no body of an army on the field against us. Being advanced as far as Truro, we had the enemy in an isthmus of land, where they could not escape us.

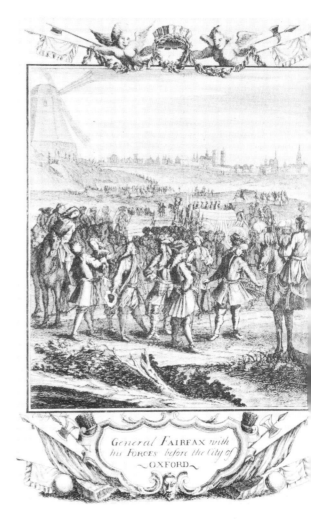

General FAIRFAX with his FORCES before the City of OXFORD

**35** The city of Oxford was the King's headquarters throughout the war. London remained in the hands of the Parliamentarians in spite of attempts by the Royalists to dislodge them. The final surrender of Oxford in June 1646 marked the collapse of the Royalist cause.

**36** The King escaping from Oxford in disguise. Hoping to evade capture the King left Oxford and fled to the North.

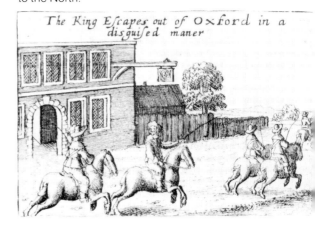

The King Escapes out of Oxford in a disguised maner

Échele de piez.

In June 1646 the King's headquarters at Oxford finally surrendered. Among his military tasks Sir Thomas did not forget that Oxford was an important centre of learning and did all he could to prevent any damage there. The writer John Aubrey, who was in Oxford for part of the war, recorded in his book *Brief Lives:*

When Oxford was surrendered, the first thing General Fairfax did was to set a good guard of soldiers to protect the Bodleian Library. . . . he was a lover of learning and had he not taken this special care, that noble library had been utterly destroyed, for there were ignorant senators enough who would have been contented to have had it so.

On 12 November 1646 Sir Thomas Fairfax arrived back in London to receive the congratulations of the city and both Houses of Parliament. He was a sick man and had been in pain for most of the war, but he had hidden his own troubles because he knew that a good general must try to set a brave example. In 1644 at the siege of Bristol he had written to his father about what to do with the trapped Prince Rupert and added, sadly:

I am exceedingly troubled with rheumatism and a benumbing coldness in my head, legs and arms, especially in that side I had my hurts.

At the end of his campaigns in the West he wrote wearily from Exeter:

**37** The Bodleian Library Oxford. The scholars of Oxford suffered considerably as hosts to the King's company during the war. Academic life was severely disrupted and it must have been with some relief that they welcomed the sensitive Sir Thomas Fairfax, especially when it became clear that he would protect their treasures from the soldiery. This beautiful library contains one of the country's most valuable collections of books. Sir Thomas Fairfax had it specially guarded.

I desire Your Lordship's pardon that I write so short and so seldom: indeed my indisposition of health is often as much the cause of it as any business.

It was time for Sir Thomas to look at his own affairs. It had been four years since he had left home so abruptly and his expenses for his men had led to confusion in his own finances:

Though now it hath pleased God in some measure to settle the general affairs of the kingdom, I should be glad to settle mine own in some more certainty . . . the public business having wholly taken up my thoughts, making me a stranger to my own business.

But the "public business" was not yet over for Sir Thomas. After the King's surrender he began the long and frustrating negotiations for peace with him. The King escaped for a short time to the Isle of Wight and made an agreement with the Scots for help. This led to the so-called Second Civil War in 1648, for which Sir Thomas wearily took up arms again.

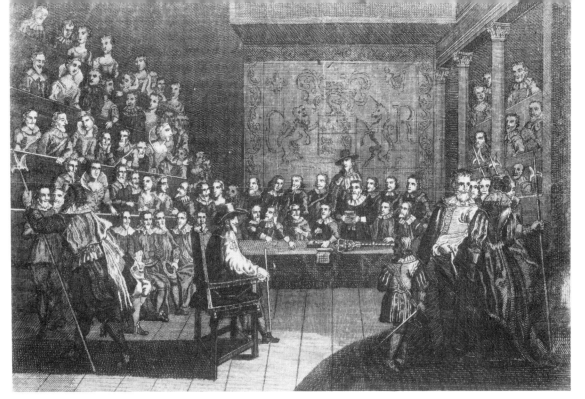

In 1649 he was called to sit on the commission set up to try the King. He could not agree with the King's execution and in 1650 he retired from public affairs. In 1660 he came out of retirement to serve on the New Commission which restored King Charles II to the throne. Sir Thomas lived on until 1671, dying at the age of 59. He was one of the noblest and most honoured soldiers on either side in this war.

**38** The Trial of the King. Charles was at his most dignified during his trial. He refused to plead, denying the authority of his judges to try him. He claimed that it was he and not them who stood for the liberty of the people. It is probably Lady Fairfax who is seen crying out at the injustice of the proceedings. Sir Thomas, disagreeing with the whole affair, had absented himself.

# Lucy Hutchinson (1620-*c*. 1680)

In 1664 John Hutchinson, the former Parliamentary colonel and Governor of Nottingham, died in Sandowne Castle in Kent. He had been imprisoned on a vague charge of treason but he had been one of the signatories of the death warrant of Charles 1. John had instructed his wife, Lucy, not to grieve for him, so she used her pen to write his life story to show her children how much she had loved and admired him. She called it *The*

*Life of Colonel John Hutchinson.*

Lucy was the daughter of Sir Allen Apsley, the Lieutenant of the Tower of London. Even as a little girl she was very studious, which pleased her father but worried her mother who, she wrote,

. . . would have been contented if I had not so wholly addicted myself to [Latin] as to neglect my other qualities. As for music and dancing, I

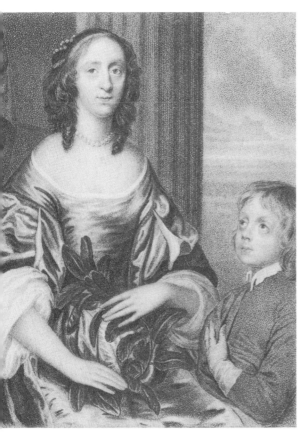

**39** Portrait of Mrs Lucy Hutchinson and her son, for whom she wrote the biography of her husband.

profited very little in them and would never practise my lute or harpsichord but when my masters were with me, and for my needle, I absolutely hated it.

Lucy's mother was worried that such a girl would not find herself a husband but it was these very books which first fascinated John Hutchinson before he even saw her. (Note that Lucy always writes about herself and her husband in the third person when she begins to write of her husband's life.)

One day when he [John Hutchinson] was there [at her home in Richmond, Surrey] looking upon an odd by-shelf . . . he found a few Latin books; asking whose they were, he was told that they were [Lucy's], whereupon inquiring more after her, he began . . . to be sorry that she was gone:

They soon met and grew to love each other. In 1638 they were married in St Andrew's Church in Holborn. Lucy was all the more precious to him because just before their wedding she had nearly died of smallpox. Lucy and her husband were very religious people. They both feared and disliked Roman Catholics, and as the Civil War loomed nearer they became convinced that the Puritan way to God was the only way and that the cause of Parliament must be the right cause. In the four years between their marriage and the beginning of the war Lucy and John studied all the papers about the quarrels between the King and his Parliament and

He [John Hutchinson] was clearly swayed by his own judgement and reason to the Parliament [and] contented himself with praying for peace.

As Puritans, Lucy and John felt discriminated against as they saw Roman Catholics favoured in the Court of the King and his French wife:

And by the King's example [the Roman Catholics] were matched [married] into the best families; the Puritans were more than ever discountenanced and persecuted insomuch that many of them chose to abandon their native country and leave their dearest relations to retire into any foreign soil or plantation where they might . . . enjoy the free exercise of God's Worship.

When the war broke out their quiet life at Owthorpe vanished for ever. Sir John became Governor of Nottingham Castle and found himself responsible for defending the town and the castle and for recruiting soldiers. He had many difficulties to face, not least from the very citizens he was trying to protect. The townsmen were not happy about defending Nottingham from inside the castle when their homes in the town would be abandoned to the enemy. Lucy felt their behaviour to be most ungrateful, considering that,

When the Governor [Colonel Hutchinson] first came into Nottingham to defend it at their earnest desire he left a house and a

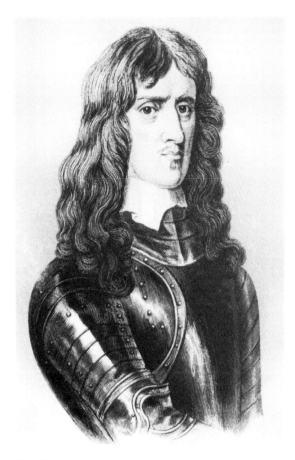

**40** Colonel John Hutchinson.

considerable estate to the mercy of the enemy.

The Colonel offered the citizens an honest choice. He told them,

You have but three ways to choose, either leave the town and secure yourselves in some other Parliament garrisons, or list into the castle, or stand upon the works and have your throats cut.

Eventually about 300 of the people of Nottingham joined the castle garrison. They began to make preparations for attack. Some of their worst problems came from troops of soldiers on their own side who, passing through on their way to other battles, took anything they needed from the local people. Of Lord Grey's soldiers Lucy reports:

Mr Hutchinson was much vexed to see the country wasted and that little part of it which they could only hope to have contribution from, eaten

up by a company of men, who, instead of relieving, devoured them.

As they prepared for the inevitable siege the local Cavaliers threatened Lucy's husband with severe consequences if they did not give up the castle to the King. A certain Mr Ayscough came on behalf of Lord Byron, Governor of nearby Newark and a relation of Colonel Hutchinson, and

. . . desired him [Colonel Hutchinson] to consider his wife and children and the loss of his whole estate, which was inevitable if he had persisted in the engagement he was in . . . but if he would return to obedience to the King, he might not only preserve his estate but have what reward he pleased . . . for so doing.

But Colonel Hutchinson would not give in. The Cavaliers arrived and took the town. The castle held firm and the Cavaliers took over St Nicholas's Church and from a platform they built on its steeple fired into the castle grounds. Lucy tended the wounded as well as she could:

From this church the bullets played so thick into the outer castle-yard that they could not pass from one gate to the other, nor relieve the guards, but with very great hazard, and one weak old man was shot the first day, who, for want of a surgeon bled to death before they could carry him up to the governor's wife, who at that time supplied that want as well as she could.

The Cavaliers were in the town for five days and then Parliamentary troops arrived from Leicester. Lucy tended the wounded of both sides, to the horror of a certain Captain Palmer, who reprimanded her for treating the enemy.

After our wounded men were dressed she [Lucy] stood at her chamber-door and seeing three of the prisoners sorely cut, and carried down bleeding . . . she desired the Marshal to bring them into her, and bound up and dressed their wounds also: which while she was doing Captain Palmer came in and told her his soul

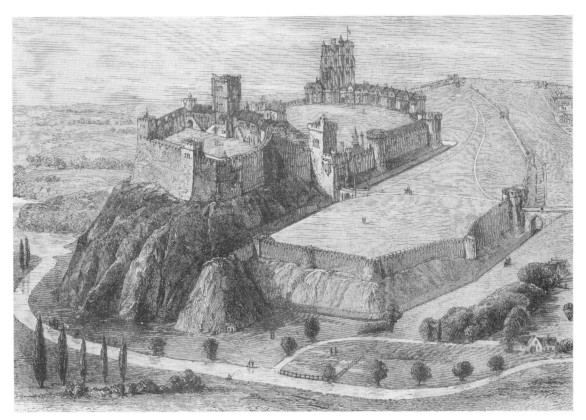

abhorred to see this favour to the enemies of God: she replied she had done nothing but what she thought was her duty in humanity to them, as fellow creatures, not as enemies. But he was very ill-satisfied with her.

In the chaos of the castle, among the wounded and the prisoners, Lucy and her husband found a relation of theirs. To their sorrow he was a Cavalier captive. All the same he was invited to supper with them, which enraged Palmer.

But the Governor took no notice of it, though he [Captain Palmer] set the very soldiers a muttering against his wife and himself for these poor humanities.

At last the Cavaliers were forced to leave Nottingham. In November 1643 Colonel Hutchinson received Parliament's instructions that he was to be Governor of the whole town as well as of the castle. This extra responsibility increased the Colonel's difficulties, because the people of Nottingham who had not already joined the garrison were not to be trusted.

**41** Nottingham Castle held a commanding position above the town, with clear views of the surrounding countryside. Although it has since been destroyed and rebuilt it is still an outstanding landmark.

First, they were almost all malignants [those opposed to Parliament]. . . . Secondly, they were not so much open, professed enemies as close, hypocritical, false-hearted people . . . Even the most upright men of the garrison were often seduced by their fair colours.

There were so many arguments and so much resistance to his orders that the defences were not complete by the time the enemy came again. The Colonel found his small garrison of about 400 men facing around 3000 Cavaliers. The enemy broke into the town with ease but the castle was strong and, to everyone's surprise, a sudden charge from the castle drove out the Cavalier foot-soldiers. After them, into the freezing winter countryside, went the men of Nottingham, finding a horrific trail to follow:

. . . For two miles they left a great track of blood

which froze as it fell upon the snow, for it was such bitter weather that the foot had waded almost to the middle in snow.

The castle and the town were not continually under siege and more frightening news reached them in March 1644. It was said that Charles I's warrior nephew, the fierce Prince Rupert, himself intended to march on the town and burn them all. Sir John prepared to hold out to the end but at the last minute, and within three miles of Nottingham;

It pleased God to divert him [Prince Rupert] from coming against the town by letters which were brought him from Oxford which occasioned his hasty return into the South.

Nottingham was saved.

After the battle of Naseby, and the King's surrender to the Scots, the tensions of war eased, but Colonel Hutchinson's work was not over, for, "He went up to London to attend his duty there and serve his country as faithfully in the capacity of a senator as he had before in that of a soldier."

When Lucy and John returned to their home at Owthorpe they found it to be in a sad state,

. . . having stood uninhabited and been robbed of everything which the neighbouring garrisons of Shelford and Wiverton could carry from it. It was so ruined that it could not be repaired to make a convenient habitation, without as much charge as would almost build another.

In the confusion and plotting between the King's surrender in 1645 and his execution in 1649 Lucy and her husband divided their lives between repairing their home at Owthorpe and John's duties in London as a Member of Parliament. He found himself one of the commissioners at the trial of the King and was called upon to sign the King's death warrant.

He prayed for God's guidance on this solemn occasion, "and finding no check but a confirmation in his conscience that it was his duty to act as he did . . . proceeded to sign the sentence against the King."

Charles was executed in January 1649 and for the next 11 years there were many changes of government as Oliver Cromwell tried and failed to find a suitable alternative to a monarchy. There was great confusion and Lucy and her husband were in the midst of it. They became disillusioned with Oliver Cromwell, especially when it became clear that the government was to be in the hands of the army. When called to Cromwell's presence John told him honestly that he could not serve him

. . . because he [John] liked not any of his [Cromwell's] ways since he broke up the Parliament, being those which would lead to certain and unavoidable destruction, not only of themselves but of the whole Parliament Party and cause.

After such a speech as this to a man who was now the King in all but name, Lucy feared that John was certain to be arrested, but

. . . before his guards apprehended the Colonel death imprisoned himself [Cromwell], and confined all his vast ambition and all his cruel designs into the narrow compass of a grave.

Two years after Cromwell's death Charles II returned as England's King. A special Act was passed in Parliament, called the Act of Oblivion, which promised no punishment for those involved in the death of Charles I. Lucy and John thought they might live quietly and in safety at Owthorpe, but it was not to be. Soldiers were sent to arrest John on a charge of being involved in a vague northern plot. He was to spend the last 11 months of his life as a prisoner. He was taken to London and placed in the Tower. Lucy did all she could to free him but her efforts were in vain. He was moved to Sandowne Castle in Kent, which was damp and uncomfortable. Lucy and her children were allowed to see him but his increasing illness often caused her to cry. In the autumn of 1664 Lucy made a hasty visit to Owthorpe and, while she was away, John died. He left a last message for his beloved Lucy, who had suffered so much for him:

**42** Sandowne Castle in Kent was built in the sixteenth century by Henry VIII to protect the coast. During the Civil War it was a useful lookout for the Parliamentarians and was used as a prison during and after. Sir John Hutchinson was not the only "traitor" to be sent to Sandowne, which, as Mrs Hutchinson noted, was remote and comfortless.

Let her as she is above other women show herself on this occasion a good Christian and above the pitch of ordinary women.

Lucy returned to Owthorpe with her husband's body and buried him there. We know that she lived some years after him. In the graveyard at Owthorpe where John is buried is this inscription, supposed to have been composed by Lucy herself:

He died at Sandowne Castle in Kent after eleven months harsh and strict imprisonment – without crime or accusation upon the 11th day of September 1664 in the 49th year of his age, full of joy, in assured hope of a glorious resurrection.

# John Hampden (1594-1643)

Without question when he first drew his sword he threw away the scabbard. (The Earl of Clarendon, *The History of the Rebellion*)

John Hampden was a man of determination. Once he had decided on a course of action he followed it with all his energy. He was one of the many Parliamentarians who took on the extra job of a soldier once the war began because he felt it to be his duty. His death in 1643 was a great loss to the cause of Parliament.

Hampden came from a wealthy family in Buckinghamshire and was the cousin and friend of Oliver Cromwell. He studied law and in 1620 became a Member of Parliament. His mother was ambitious for her clever son and hoped that he would become a peer, but Hampden's ambitions were in a different direction. He was a convinced Puritan and believed in the rights of Parliament. He was prepared to take a stand on what he believed to be right and he deliberately brought on himself the famous Ship Money Trial in 1637. Ship Money was a tax levied on coastal towns to provide money to build ships for the navy. In 1635 and 1636 Charles ordered the whole country to pay the tax. John Hampden

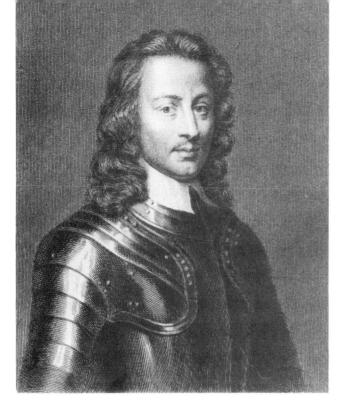

**43** Portrait of John Hampden.

**44** John Hampden's house in Buckinghamshire. He came from a comfortable, middle-class family and was typical of many Puritans who supported the cause of Parliament. Many such prosperous and peaceful homes and their families were broken up and bereaved by the war.

claimed that the King was acting illegally because there was no Parliament to agree to it. In 1637 he refused to pay. The case came to court and the King won by a narrow majority. John Hampden had become famous.

His constant opposition to the King in the years before the war caused great irritation to Charles I and his ministers. Thomas Wentworth, Charles' chief minister, wrote of him in exasperation:

In truth I still wish Mr Hampden and others of his likeness were well-whipped into their right sense, and if the rod be so used that they smart not, I am the more sorry.

Even his enemies could not deny his honesty or his popularity with the people. The Earl of Clarendon, who supported the King, wrote of him:

I am persuaded, his power and interest, at that time, was greater to do good or hurt, than any man's in the Kingdom, or than any man of his rank hath had in any time: for his reputation of honesty was universal, and his affections seemed so publicly guided, that no corrupt or

private ends could bias him. (*History of the Rebellion*)

John Hampden could have enjoyed the affluent life of a wealthy country squire but with the opening of the last Parliaments before the war (the Short and Long Parliaments) he sacrificed his pleasant family life for ever.

Hampden's opposition to royal policy led to the King's famous attempt to arrest him and four others. They were warned that the King was coming and fled. Hampden received great support from the country. Four thousand marched to London to see the King for him. In each of their hats was a copy of their petition

. . . that having by virtue of your highness' writ chosen John Hampden, knight, for our shire, in whose loyalty we, his countrymen and neighbours have ever had good cause to confide, of late, we, to our less amazement than grief, find him with other Members of Parliament accused of treason . . . we most humbly pray that Mr Hampden and the rest . . . may enjoy the just privileges of Parliament.

The proceedings against Hampden were dropped, but the move towards war continued. Hampden did not wish to be disloyal to the King but he sincerely felt that the King was opposing freedom in religion and the rights of Parliament. He wrote:

To deny obedience to a King, commanding anything against God's true worship and religion or against the ancient and fundamental laws of the land . . . is the duty of a good subject.

Once his duty was clear to him Hampden set to work to organize the war. He became a member of the Committee of Public Safety set up by Parliament and was responsible for recruiting a regiment of foot soldiers in his own area. He was appointed Colonel and his troop was called the "Greencoats". They were humble men with few weapons. Hampden held his first muster at Chalgrove field, 14 miles from his home. (It was in this field that he was to receive his fatal wound the following

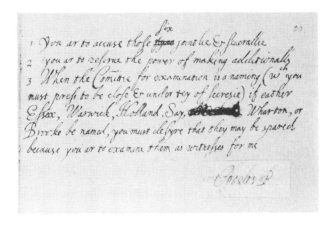

**45** The impeachment of the five members. The instructions for the impeachment come from the King and were given to the Attorney General, Sir Edward Herbert. The five members, including John Hampden, were to be impeached for their disobedience to the King. When the King came to the House to arrest them himself they had already fled.

year.) Hampden looked anxiously at his troops. They had brought what weapons they could. Some carried agricultural tools; others had taken down ornaments from their walls: crossbows and swords, some of them relics of the Wars of the Roses. Hampden equipped and encouraged them as best he could. They might be humble and ill-equipped but they were loyal and determined.

Hampden was tireless in his new role as a soldier. He urged his men on in battle, sometimes under terrible conditions, and he sent regular encouraging messages to his officers, like this one in November 1642:

Gentlemen . . . The army is now at Northampton, and moving every day nearer to you. If you disband not, we may be a mutual succour [help] to each other, but if you disperse, you make yourself and your country a prey.
<div style="text-align:center">you shall hear daily from,<br>your servant,<br>John Hampden</div>

Hampden's personal enthusiasm, sometimes in the face of great difficulty, is clearly explained in this almost breathless account to his cousin, Cromwell. He was speaking of the attack on Brainsford:

We were in jeopardy: and many forced by the

sword into the hedges and the water, there to drown. But yet none fled, cousin. We stood it out by God's help, with much ado and made it good until our friends from London came to our relief. Nor were we left so scant of breath by choking dust and black of artillery, but we could yet follow the enemy a pretty space through Kingston and sing a Psalm of joy with thanksgiving, when deliverance was assured and the day was ours.

Although he never spared himself, and the engagements fought by his own troops were noted for their energy, Hampden felt that something was wrong in the attitude of his own side. The decisive, sharp victory he longed for was slow in coming. Many on Hampden's side wanted to come to terms with the King and Hampden felt that this attitude did not inspire the necessary fervour for victory among the men.

As far back as 1643 Hampden had urged the formation of a new, inspired and well-organized army for Parliament. This New Model Army was not to be created until after his death and meanwhile Hampden must obey the orders of superiors more timid than himself. He had to content himself with raising men and money and riding daily between the early morning debates at Westminster and his Greencoats at Windsor.

In the spring of 1643 Hampden wanted to make a decisive attack on the King's headquarters at Oxford. He asked the General of all Parliament's army, the Earl of Essex, if he could "strike at the root". Essex was not as decisive as Hampden wished and ordered him to the famous siege of Reading, where he led the advanced forces. It was still not good enough for John Hampden, as he said to Cromwell, "Well and manfully did we enter on our duties. Lazily and mournfully do we pursue them."

The first year of the war had brought its successes, but for Hampden it was not enough. Certainly his side had done well

. . . and yet is that success which we had hoped for from a short fierce struggle as remote as when the King of England's standard was first

raised and his sword drawn forth against her people and her laws in August last.

On 18 June 1643, in a skirmish in Chalgrove field, Hampden was injured. According to Clarendon in his *History of the Rebellion* Hampden was "shot into the shoulder with a brace of bullets which broke the bone". At the time he had been urging on his men and when

**46** During the years 1642 to 1644 Charles I issued some gold pieces worth 60 shillings (£3) each, all of which were coined at Oxford. On this one, which is the finest and most rare, the King promises in Latin "to preserve the Protestant religion, the known laws of the land and the just privileges of Parliament". The coin is now in the British Museum.

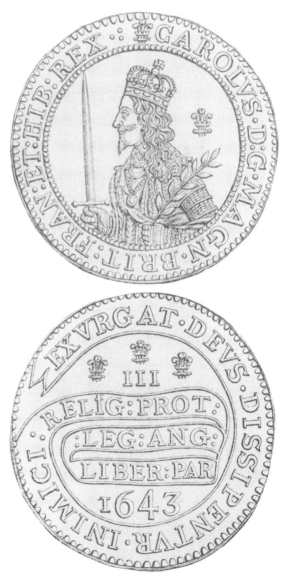

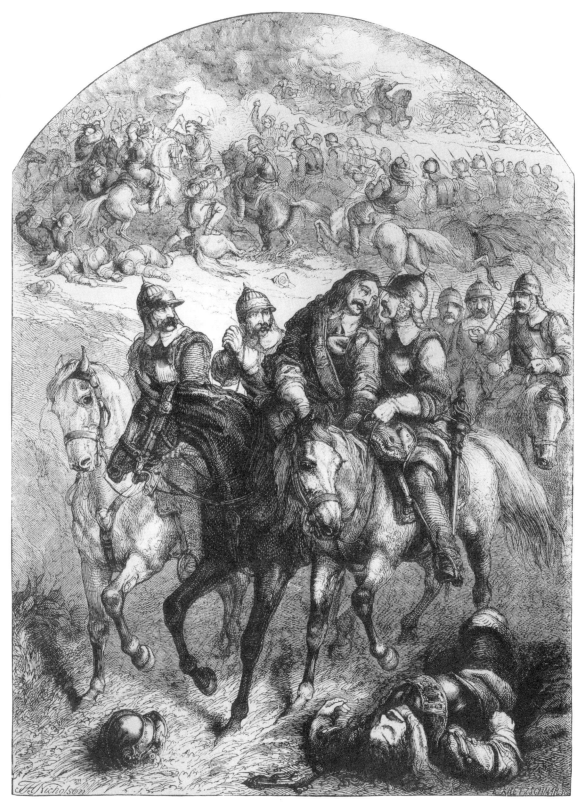

**47** Hampden wounded at Chalgrove Field. This dramatic Victorian reconstruction is obviously by an artist who felt sympathy for the Parliamentary cause. In the background the ferocious battle contines, while in the foreground all is quiet dignity as the fatally wounded Hampden is led from the field by his grieving fellow soldiers.

he was shot he rode straight from the battlefield to Thame, where, in the house of one Ezekiel Browne, his wounds were dressed. At first it was thought he might live, and indeed he struggled on for six days in great pain. According to reports, his last prayer was for his King and country. The *Weekly Intelligencer*, printed a week after his death, records:

The loss of Colonel Hampden goeth near the heart of every man that loves the good of his King and country, and makes some conceive little content to be at the army now that he is gone. . . . He hath left few of his like behind him.

Sir Philip Warwick recorded that even the King was affected by Hampden's death. Charles I had seen in him a level-headed man who, had he lived, might have helped to sort out his difficulties with Parliament:

The King, being informed of Mr Hampden's being wounded, would have sent him over any surgeon of his if he had been wanting: for he looked upon his interest, if he could gain his affection, as a powerful means of begetting a right understanding between him and the two Houses. (Sir Philip Warwick, *Memoirs of the Reign of Charles I*)

Hampden would certainly have been pleased with the more decisive actions of his comrades after his death. The New Model Army was formed and the able Cromwell and Fairfax, both of whom had a true determination to win, took control. He would not have been pleased to know that the war was to continue for many years longer. The bust of Hampden at Stowe carries this inscription, which sums up a man, devoted so energetically to his cause:

With great courage and consummate abilities, he began a noble opposition to an Arbitrary Court in defence of the liberties of his country: supported them in Parliament, and died for them in the field.

# Nehemiah Wharton

In 1642 the excitement of fighting inspired many men to join the army on both sides. Some of the volunteers joined because they believed in the cause of the King or his Parliament but many more saw it as a great adventure. Nehemiah Wharton was one of these volunteers. During this first year of the war he wrote regular letters to his former master and friend Mr George Willingham, a merchant at the Golden Anchor in St Swithin's Lane. These letters were published in 1853.

Wharton joined the army of the Earl of Essex, and his letters show that he was a full supporter of the cause of Parliament, but there is no doubt that he enjoyed his soldiering too. We have this description of the excitement of

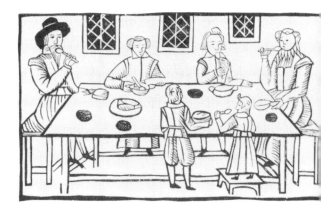

**48** A Puritan family meal in the early seventeenth century. Note how simple is the dress of the family and how plain the fare. The children are standing at the table to eat their food, which was considered good discipline by Puritan parents.

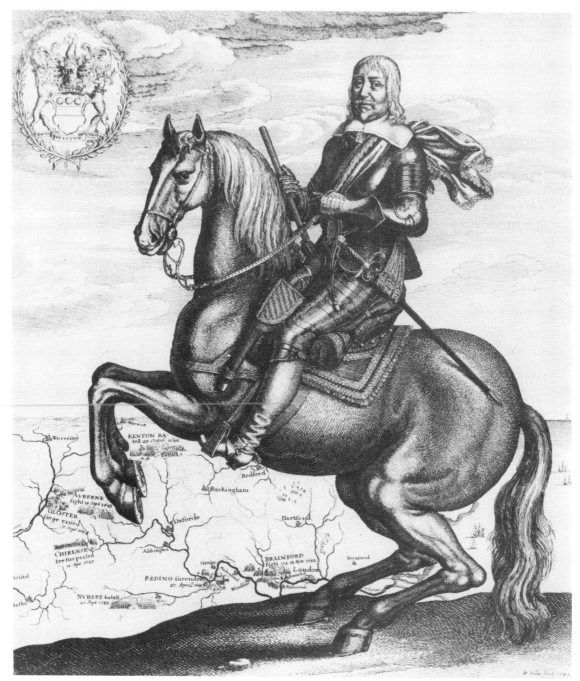

## London at the formation of Nehemiah's regiment written by an observer:

How forward and active the Londoners were to promote this rebellion can hardly be imagined: people of all sorts pouring out their treasures as if it had been for the most adventurous purchase in the world: thronging in with their plate and rings and not sparing their very thimbles and bodkins. Neither were they backward in the

**49** Robert Devereux, Earl of Essex, Lord General of Parliament's forces. Behind this noble picture of the Earl of Essex is a map showing the places of his armies' successes.

adventure of their lives: five thousand of them listing themselves under the Earl of Essex the next day in Moorfields, which, with the other volunteers then in readiness, amounted to near 10,000 men, being forthwith committed to

officers and distributed into regiments, were ordered to be daily exercised and have constant pay. (Dugdale, *Short View of the late Troubles in England*, 1681)

Among this 10,000 was Nehemiah Wharton, who was given the rank of sergeant in the Redcoats of Colonel Denzil Holles. In the middle of August 1642 the army marched away. As they marched they attacked those who supported the King's side and who were, therefore, their enemies. All Roman Catholics were badly treated because, being Parliamentarians, Sergeant Wharton's men were Puritans. Thus, they thought there was no harm in mistreating any unfortunate Roman Catholics who crossed their path. The army stopped for the night at Acton on their way north and spent some time in what they considered to be "God's Work", but which we would probably call cruel vandalism:

Early in the morning several of our soldiers inhabiting the out parts of the town [of Acton] sallied out into the house of one Penruddock, a Papist and being basely affronted by him and his dog, entered his house and pillaged him to the purpose. This day also the soldiers got into the Church, defaced the auntient and sacred glassed pictures and burned the holy rails.

To Sergeant Wharton and his men this was perfectly acceptable behaviour and the very next day he noted,

Mr Love gave us a famous sermon this day, also the soldiers brought in the holy rails [of the Church] from Chiswick and burned them.

These men were not all experienced soldiers and Wharton records a horrible accident with surprising calmness. Clearly, this was all part of a normal day in the army to him:

We came to Wendover where we refreshed ourselves, burnt the rails [in the Church] and, accidentally, one of Captain Francis' men, forgetting he was charged with a bullet, shot a maid through the head and she immediately died.

Finding food and shelter for large troops of soldiers was always a problem. The local people were expected to give them supplies and a roof, and what was not given freely was taken by force:

Everyday our soldiers do visit Papist houses and constrain from them both meat and money. They [the poor residents] give them great loaves and cheeses, which they triumphantly carry away on the point of their swords.

This behaviour could often lead to great cruelty.

**50** This "open scene" of a house shows the behaviour often experienced by the unhappy owners of a house visited by soldiers of the opposite side. In the cellar the barrels are broken open, while in the dining room the intruders collect up the valuable plate. The owner holds his head in despair – or perhaps injury – in the middle picture. At the top of the house they have found their way into an occupied bedroom.

**51** "The Lord's Day". This Puritan pamphlet of 1639 ▶
sets out the Puritan code of behaviour for the Lord's
Day. In the left-hand column are the works of Light,
including prayer, Church attendance, Bible reading,
sick-visiting and helping the poor. On the right are the
Works of Darkness: drunkenness, dancing, card-
playing, feasting and working.

This day our horse-men sallied out as their daily
custom is, and brought with them two Cavaliers
and with them an old base priest . . . and led him
ridiculously about the city.

Obviously this type of behaviour did not make
the army very popular in the towns and
villages through which they passed and their
commanders tried to restrain their men:

Thursday, August the 26th our soldiers pillaged
a malignant fellow's house in this city [Coventry]
and the Lord Brooke immediately proclaimed
that whoever should for the future offend in that
kind should have martial law.

Poaching was a different matter. The
officers often turned a blind eye to this,
especially if the spoils were shared with them!
One morning Nehemiah gathered some of his
men and went out to find some supper in this
way.

Marched to Sir Alexander Denton's park, who is
a malignant fellow, and killed a fat buck,
fastened his head upon my halbert and
commanded two of my pikes to bring the body
after me to Buckingham . . . with part of it I
feasted my captain (and other officers) and had
much thanks for my pains.

There were many quarrels and arguments
among the soldiers themselves and, as
Nehemiah found to his cost, they were not
above stealing from each other:

There is also great dissension between our
troopers and foot-companies, for the footmen
are much abused and sometimes pillaged and
wounded. I myself have lately found it, for they
took from me about the worth of £3. But I am not
discouraged by any of these, but, by God's

assistance, will undauntedly proceed, for God is
able to reconcile our differences.

In common with many Puritans, Nehemiah
enjoyed the services in church, especially the
sermons. One day while the sermon was in
progress news was rushed in that the enemy
was nearby. Nehemiah was determined that
God must come first.

News was brought into the church unto our
commanders that Nuneaton, some six miles off,
was fired by the enemy, and forthwith our
General and several Captains issued forth, but I
and many others stayed until the sermon was
ended.

Uniform for the soldiers could present a
problem. They provided their own if they
could and Nehemiah, like many others, took a
pride in his appearance. He had a kind master
who eased his difficulties by sending him
useful presents:

Monday morning I received your letter . . . with my mistress's scarf and 'Mr Malloyne's hatband both of which came very seasonably, for I had gathered a little money together and had this day made me a soldier's suit for winter edged with gold and silver lace. These gifts I am unworthy of. I have nothing to tender you for them but humble and hearty thanks. I will wear them for your sakes, and I hope I shall never stain them but in the blood of a Cavalier.

Through the summer and into the early autumn the army marched on into the Midlands. This was wild, inhospitable countryside and quarter was hard to find. Nehemiah's companions were becoming fractious and quarrelsome because as yet they had not encountered the enemy's soldiers and they were anxious to be fighting. When they came within range of Holmby House, which was Royalist and the home of the Earl of Northamptonshire, it was only with great difficulty that the officers prevented the men from ransacking it, ". . . but we could not restrain our soldiers from entering his park and killing his deer."

The troop approached Worcester and, at last, the news came that they would have some real fighting:

Upon this report [of an attack to be made on Worcester] our whole regiment ran shouting for two miles together, and crying "to Worcester, to Worcester" and desired to march all night.

The King's nephew, Prince Rupert, had already visited the town, and the inhabitants sent reports of the cruel way in which the Cavaliers had treated the Parliamentary soldiers they had found there, which Nehemiah records:

Our wounded men they brought into the city, and stripped, stabbed and slashed their dead bodies in a most barbarous manner and imbrued [stained] their hands in their blood. . . . They also met a young gentleman, a Parliment man, (his name I cannot learn) and stabbed him on horseback with many wounds and also, most maliciously, shot his horse.

Nehemiah and his men were keen to go and attack Rupert but they did not know where he and his men had gone. They were still a day's march from the town of Worcester and so prepared for another miserable night in the countryside:

We had small comfort, for it rained hard. Our food was fruit, for those who could get it, our drink, water, our beds, the earth, our canopy, the clouds. . . . But we pulled up the hedges, pales and gates and made good fires. . . . Thus we continued singing psalms until the morning.

The next day they entered Worcester and buried their dead. Nehemiah and his men wanted revenge:

We shortly expect a pitched battle, which if the Cavaliers will but stand, will be very hot, for we are all much enraged against them for their barbarianisms and shall show them little mercy.

To Nehemiah's sorrow he missed the skirmish with Rupert but was told it by some of the officers. The Prince had ambushed the troop and defeated them. Nehemiah was not disheartened and looked forward to the next encounter, which he was sure would be successful:

They [Prince Rupert's men] boast wonderfully and swear most hellishly that the next time they meet us they will make but a mouthfull of us; but I am persuaded the Lord hath given them this small victory that they may, in the day of battle, come on more presumptuously to their own destruction.

As the winter drew on Nehemiah and his men left Worcester and marched through the snow to Hereford. This was a Royalist town and the citizens had been promised Cavaliers to help them if they could hold out. Thus the gates were locked and the army stood outside in the cold and mud, one of their number already having died from exposure. The citizens had few weapons but fought hard with the little they had:

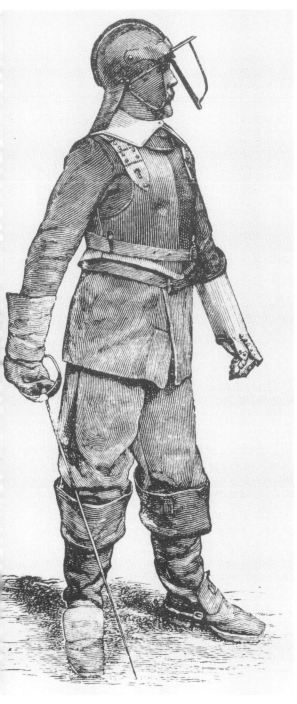

And having in the city three pieces of ordinance they charged them with nails and stones and placed them against us and we against them, resolving either to enter the city or die before it.

One of the few Parliamentary supporters in Hereford managed to trick the city into opening its gates and the troops marched in. Nehemiah found it a beautiful city but he did not think much of its Royalist people:

The inhabitants are totally ignorant in the ways of God, and much addicted to drunkeness and other vices, but principally unto swearing so that the children that have scarce learned to speak do universally swear stoutly.

His loyal Puritan heart was most offended on Sunday when he found "shops open and men at work, to whom we gave some plain exhortations".

Nehemiah's men went to the minster for the Sunday service and, as good Puritans, they felt that free expression of their enjoyment of the music was necessary. Therefore they danced to the choir and organ. This did not please the citizens, and they were even less pleased when the soldiers interrupted the prayers. When prayers had been offered for the King and his bishops one of the soldiers stood up and shouted; "What! Never a bit for the Parliament?".

Nehemiah Wharton's letters come to an abrupt end on 7 October 1642. It is interesting to speculate on what became of him. Perhaps he was one of the many casualties in the battles of the Earl of Essex's army. It is just possible that he might have lived and continued to write letters to his master but that they have been lost to us.

**52** British light horseman *c.* 1645. Life in Cromwell's New Model Army was strictly regulated. There were heavy punishments for indiscipline. This soldier is wearing the uniform of a Light Horsemen and yet he wears metal breast and back plates, a gorget round his neck, a heavy helmet with a lobster shell neckpiece, and a steel rein-arm guard on his right hand.

# THE FALLING OUT

It was reported that at the Battle of Edgehill an old Royalist found himself faced by a musket at point-blank range. He wept as he died, not because he was afraid of death but because it was his own brother who shot him. A civil war, especially one in which the early issues were not clear, was bound to lead to such heart-breaking instances. Most English people, whatever their views, looked on the prospect of war with horror. In his *History of The Rebellion* Clarendon wrote:

The number of them who desired to sit still was greater than those who desired to engage in either party.

To be neutral was not easy. It led to each side suspecting loyalty to the other. Indeed, some people who formed groups called "Clubmen" to protect themselves and their property from both armies were accused of being traitors by both. To "sit still" was not easy when a huge army approached and soldiers demanded to know whether one was for King or for Parliament. There is some truth in the idea that a large number of people did not actually care about the war at all. In the seventeenth century life was hard enough without complicating matters further by organized bloodshed for principles not clearly understood. Hazelrigg, a Parliamentary politician, wrote of the ordinary working people with exasperation:

They care not what government they live under, so they may plough and go to market.

It was also true in these hard years that soldiers of both sides deserted regularly to tend their precious crops. One of Fairfax's generals wrote in 1644:

Sir, I have endeavoured to get my soldiers into order, fit for service to advance on Nantwich; but they are disbanding themselves and are following the plough and from thence they will not be drawn.

Some people found themselves serving the opposite side by accident, as in the case of Adam Martindale, whose family loyalties were Royalist but who found it safer, under the circumstances, to agree to become a clerk in Parliament's army. Personally, he would have prefered no part in the war at all.

Those who felt deep commitment to either side often found themselves at odds with their neighbours and even with their own families. Great courage was shown by those who had the misfortune to be isolated in an area supporting the opposing side: Puritan Lady Brilliana Harley found herself, without her husband and sons, defending her family home in a Royalist neighbourhood. It took strong principle to stand firm against the closest members of one's own family, especially when they sent letters such as this one from Royalist Lady Denbigh to her Parliamentary son:

Oh my dear son, that you would turn to the King. . . . At this time I do more labour with sorrow for the grief that I suffer that ever I did to bring you into the world. (*Royalist Father and Roundhead Son, The Memorials of the First and Second Earls of Denbigh, 1600-1675*)

# Brilliana, Lady Harley (1600-43)

Brilliana Conway was born in 1600. Her father, Lieutenant Conway, was Governor General of Brill in the Netherlands and named his baby daughter after this town. Brilliana grew up in Brill, where many people were Calvinist, and she adopted this form of Protestantism for herself. When she was 23 she was married to Sir Robert Harley, a Puritan Member of Parliament. Her husband's Parliamentary career often called him to London and Brilliana was left to bring up her seven children and look after the family home of Brampton Bryan Castle in North Herefordshire. Her son Edward (Ned) was born in 1624 and she wrote many letters to him when he was studying in Oxford and afterwards when he joined his father in London. These letters were published as a book in 1854.

The castle was in Royalist country and

**53** Portrait of Lady Brilliana Harley.

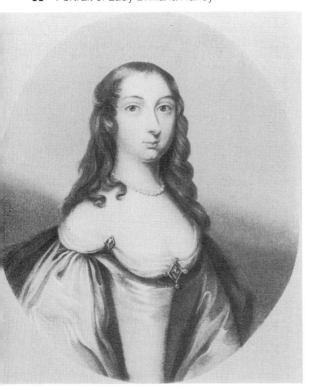

Brilliana had many Royalist relations. In the years before the war Brilliana realized that she was isolated and she began to feel worried. As the months went by the discontent spread to the country, the tenants of the castle estate began to take advantage of the situation and refused to pay their rent, with the excuse of "loyalty" to the King.

By 1641 rumours were reaching Brampton Bryan of the heated quarrels between King and Parliament. Brilliana's husband, her son Ned and one of her daughters (Brill) were in London at this time. Brilliana packed up cake and socks for her family, but she wrote of her worries too:

We hear of many more plots: one that London should have been set on fire and many plots against the Parliament; that there were porters appointed to take notice of every Parliament man's lodging. I pray you write me word whether it were so or no. I desire to trust in the Lord and that does stay my heart or else I should be in such a way that they [the Parliament] may settle their affairs, so as they have a time to go into the country, where I long to see your father and you.

Meanwhile, at home in the country, their neighbours had become openly hostile. Brilliana believed that the cause of Parliament was right and that God would help her, but the local attitude towards Sir Robert made her very angry:

It has very much troubled me to see the affections of this country so against your father that is worth thousands of them, and he has deserved so well of them, but you are in the right. It is for God's cause and then it is an honour to suffer.

Brilliana was not a strong woman and she often needed to call on the local doctor to treat her many "great colds", which were probably not helped by living in a draughty castle. Dr

Wright became her friend and eventually he and his family moved into the castle. He was of more comfort to her than were her own family, many of whom were Royalist and did not approve of their Parliamentary relations. In May 1642 she wrote sadly to Ned;

This day I heard out of Lincolnshire. I thank God they are all well: but I see my brother Pelham is not of my mind. I think now my dear sister was taken away that she might not see that which would have grieved her heart.

In the summer of 1642 the people of the neighbourhood grew unpleasant and even their traditional maypole was sinister. Brilliana began to be afraid:

At Ludlow they did set up a maypole and a thing like a head upon it and so they did at Croft and gathered a great many about it and shot at it in derision of Roundheads. . . . I acknowledge I do not think myself safe where I am. I lose the comfort of your father's company and am in but little safety but that my trust is in God. . . . I wish

**54** In this dramatic picture a poor Parliamentary gentleman, hopelessly outnumbered, is obviously surprised by triumphant Royalists. An enforced toast to His Majesty is being demanded, while the King's portrait looks upon the scene with apparent satisfaction.

myself with all my heart at London. . . . But if your father think it best for me to be in the country, I am very well pleased with what he shall think best.

Brilliana's oldest neighbours still visited her, but even old acquaintances had become unfriendly:

Sir William Croft came to see me. He never asked how your father did: spoke slightly and stayed but a little. . . . Your father they are grown to hate. I pray God forgive them. My dear Ned, I am not afraid but sure I am, we are a despised company.

In July of 1642, like many other families, Brilliana wisely packed up the family's silverplate to send to her husband in London. She put a cake in the hamper, perhaps to disguise its true contents. Brilliana was a religious lady and, like a true Puritan, she believed that God was on their side. She was anxious that her son should be strong in spite of all their worries and fears:

By the enclosed paper to your father you will know how poor Herefordshire is affected but, dear Ned, I hope you and myself will remember for whose cause your father and we are hated. It is for the cause of our God, and I hope we shall

be so far from being ashamed of it or troubled that we bear the reproach of it, that we shall bind it as a Crown upon us.

Preparations were made to defend the castle and Brilliana and her family waited in fear for the distant tramp of boots which would announce the arrival of their enemy. Brilliana often felt like running away but she thought it was her duty to stay:

My dear Ned, At first when I saw how outrageously this country carried themselves against your father my anger was so [up] and my sorrow, that I had hardly patience to stay. But now I have well considered if I go away I shall leave all that your father has to the prey of our enemies which they would be glad of, so that please God, I propose to stay as long as it is possible, if I live.

The enemy arrived – at first in small groups, who stood around shouting up the frightened family and damaged much of the outside property which belonged to the castle and prevented anyone entering or leaving. Brilliana heard that a full Royalist plan to take the castle had been worked out and it confirmed her fears:

Nine days past My Lord Herbert was at Hereford, where he stayed a week. There was held a council of war what was the best way to take Brampton Bryan. It was concluded to blow it up and which council pleased them all. The Sherrif of Radnorshire with the trained bands of that county and some of the Herefordshire soldiers, were to come against me. . . . Now they say they will starve me out of my house. They have taken away your father's rents and they say they will drive away the cattle, then I shall have nothing to live upon.

She suspected an unscrupulous plot to murder herself and her family:

For all their aim is to enforce me to let those men I have go that then they might seize upon my house and cut our throats by a few rogues and then say they knew not who did it.

In the seventeenth century there were distinctive "siege rules", which both sides obeyed. The first stage was for the besiegers to send a note demanding surrender. It was not long before the dreaded note was delivered to Brilliana, threatening her with serious consequences if she did not give up the castle. Brilliana managed to smuggle out a letter to her son:

**55** Brampton Bryan Castle after its destruction by the Royalists.

Here I have sent you a copy of the summons [which] was sent to me . . . that if I do not give them my house and what they would have, I shall be proceeded against as a traitor. . . . I hear there are 600 soldiers appointed to come against me.

The siege began on 25 July 1643. Nearly 700 soldiers waited for her surrender and Sir William Vavasour, their commander, asked her to give in, promising protection for her family if she agreed. Brilliana stood firm.

The Royalist tactics became nastier. They began to shout vile insults at the castle and then they fired, using poisoned bullets:

Her [Brilliana's] cook was shot by a poisoned bullet, and a running stream that furnished the village was poisoned. Church, vicarage houses and mill all belonging to the castle, all destroyed. ("Notice of the Rectors", quoted in *The Letters of Lady Brilliana Harley*)

Brilliana was a problem for the Royalists. Her relations were themselves Royalists and one of her cousins, Sir John Scudmore, was among the soldiers outside, but the worst problem was that she was a woman and her bravery was being reported outside the area. The King himself sent Brilliana a letter. It was delivered by her "enemy" cousin, Sir John, who climbed into the castle on a rope ladder. Brilliana told the King that in law this was her property, but she agreed she might now give it to him if all her family could leave in peace. Suddenly, the siege seemed to end when the soldiers were called away to deal with another matter, in the Forest of Dean. But by October they were on their way back. Brilliana was ill. She wrote to Ned in October 1643, and it was to be her last letter:

I wish you were at Brampton. I am now again threatened, there are some soldiers come and three troops of horse to Hereford with Sir William Vavasour and they say they mean to visit

Brampton again. . . . I have taken a very great cold which has made me very ill these 2 or 3 days But I hope the Lord will be merciful to me in giving me my health, for it is an ill time to be sick in.

Her "great cold" proved fatal. She died in that same month. Within three weeks Brilliana's good friend, Doctor Wright, ordered the castle to surrender. Sixty-seven men, 100 arms and two barrels of gunpowder were taken, but, worse, Brilliana's three younger children were taken in captivity to Ludlow Castle. It was due to their mother's bravery that they were well treated. It was recorded by an admirer that she who, throughout the siege "commanded in chief, I may truly say, with such masculine bravery, both for religion, resolution, wisdom and warlike policy, that her equal I never saw".

The castle itself was destroyed but the Harley family prospered in the future. Brilliana's beloved son Ned was impeached by Cromwell and banished from Herefordshire for 10 years. He became a Royalist and was an M.P. during the reign of Charles II. Brilliana's

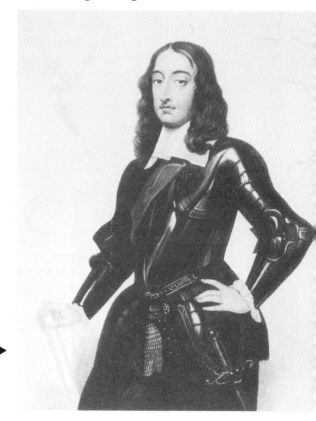

56 Sir Edward (Ned) Harley, eldest son of Sir Robert and Lady Brilliana Harley, Governor of Dunkirk 1660-1. ▶

grandson was another noted politician. When her husband, Sir Robert, died the minister conducting the funeral service spoke of his brave wife Brilliana:

That noble lady, lady and phoenix of women, died in peace. Though surrounded with drums and noise of war, yet she took her leave in peace. The sword had no force against her.

# Adam Martindale (1623-86)

Adam Martindale was 19 when the Civil War broke out. He was one of the many who were drawn into the conflict against their will. He wrote an account of his life, which was later published, in which he tells of his experiences during the war.

Adam Martindale was born in Prescot in Lancashire. His father was in the building trade, probably a mason or a carpenter. From an early age his family knew that he was a clever little boy and would grow up to be a scholar. They were not rich but Adam wanted to learn, so, in spite of all the difficulties, he got himself to a school.

I was sent to the Free School of St Helen's, almost two miles from my father's house, a great way for a little, fat, short-legged lad (as I was) to travel twice a day: yet I went cheerfully, such was my innate love of learning.

Adam studied hard and by 1642 he was looking forward to going to university, but this was the year the war broke out. To his horror he found "Oxford (whither I was designed), turned into a garrison and many scholars into soldiers". Soldiering was not for young Adam. Nineteen-year-old boys like himself were joining both sides in large numbers but Adam took a job teaching a Mr Shevington's children in the town of Eccles in Lancashire. He was inexperienced and found his job unpleasant. Neither his master nor his master's children were kind to him:

His sons also which I taught gave me great occasion for the exercise of patience for they were just like him and so encouraged by their parents and flattering servants, that I would almost as soon have led bears as take the charge of such ungovernable creatures.

The war came closer to Lancashire and Adam found himself helping his Royalist master fortify his house. Just before Christmas Mr Shevington heard that his neighbour at Wigan had been plundered by Parliamentarians. Adam decided it was time to leave Mr Shevington's service. He heard from his father that the family business was ruined by the war, for "who would either build or repair a house when he could not sleep a night in it with quiet and safety?" Adam's whole family was affected. Their sympathies were Royalist and Adam's sister was one of the earliest to suffer:

My sister was married to a noted Royalist and going to live about two miles from Lathom, which the Parliament's forces accounted their enemies' headquarters, they were sadly plundered by those forces passing the road wherein they dwelt.

For a young man who did not want to fight there was the constant danger in these years of war of being rounded up into the army by the local musters. At these meetings both sides collected their troops from the neighbourhood and sometimes in the roughest way. Henry Martindale, Adam's older brother, was to suffer in such a manner:

**57** The local militia were the nearest England had to a permanent army. They were local men called upon in time of trouble for the defence of their areas. Parliament was anxious to gain control of these important military groups and introduced a Militia Bill for the purpose in 1642, which was strongly opposed by the King. Note the bandolier worn by the infantryman on the left, which contains his charge cases and powder flask.

My brother Henry, who was then about twenty four years of age, knew not where to hide his head for my Lord Derby's officers had taken up the custom of summoning such as he and many older persons upon pain of death, to appear at General Musters and thence to force them away [into the army] with such weapons as they had, if they were but pitchforks, to Bolton, the rear being brought up with troopers that had commission to shoot any such as lagged behind.

Avoiding the army was now Adam's main concern and he went to the parish of Wigan to be a teacher. He found himself lodgings in a public house, but life was made most uncomfortable "by the disturbance given us by the soldiers often quartering among us to the depriving us of our beds and chambers".

When he was suspected of being a Parliamentarian Adam thought it was time to move on again. He came to Rainford, where he opened a "free" school. The idea of such schools was that the parents would take it in turns to feed him. They did not do so, and while he had plenty of pupils, he had nothing to eat. Neither could he turn to his family for help, for terrible news had reached him of his father, "Whose house had been so ransacked and stripped by rude soldiers that he had scarce necessary goods left him for the plainest sort of house-keeping".

Poor old Mr Martindale had suffered very badly and Adam's account of it is an example of the cruelty which was often exercised by both sides in this conflict, especially towards the lower classes, who could not easily defend themselves, physically or vocally.

For they took the old man [Adam's father] prisoner and used him most barbarously, forcing him to march in his stockings without shoes and snapping his ears with their firelock pistols. His house they plundered of everything they thought worth carrying away in carts, which they brought to his door to that purpose and were sore troubled that the walls, being stone, and the roof well shot over within, they could fasten no fire upon the house, though they several times essayed to do so.

What was Adam to do? He had no money and no job. Help came at last, but not the help he wanted. He was approached by the Parliamentary Colonel Moore (Member of Parliament for Liverpool) and offered a job as clerk to his army. This was the wrong side and a military job, but Adam had little choice. He was in need of work and to refuse might have meant that he would be forced to fight. Reluctantly, Adam accepted. He did not think much of the Colonel's family:

An hell upon earth as was utterly intolerable, there was such a pack of arrant thieves that it was scarce possible to save anything out of their hands except what I could carry about with me or lodge in some other house.

Surprisingly, life in the army did not begin as badly as he had expected. He became clerk to the regiment's foot soldiers and he did not find the work too exacting. Best of all, it kept him out of the dreaded fighting:

My work was easy enough, and such as gave

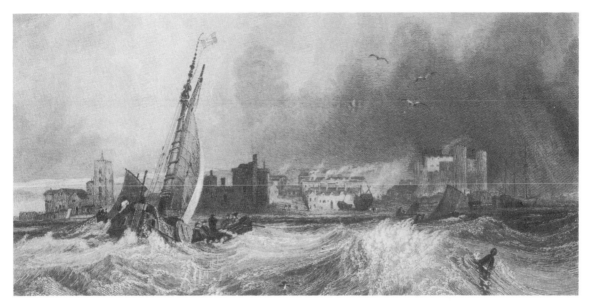

me time for my studies, being only to keep a list of the officers and soldier's names and to call them upon occasion. Nor was I to carry either musket, pike, halbert or any other weapon . . . only for fashion sake I wore a sword, as even ministers in those early days ordinarily did.

It was not long, however, before Adam was plotting to escape the army and return to his beloved teaching. He heard of a school being set up at a place called Sefton, not far from Liverpool. The local minister was known to Adam and he could not wait to get away:

I being very weary of vagarying about with soldiers and desirous to be in mine own element again prevailed with him [the minister] to nominate me for school-master, as accordingly he did.

It was not to be. Adam's troop was suddenly sent to Liverpool to defend it against the King's soldier nephew, Prince Rupert. On 26 July 1644 the town of Liverpool surrendered to the Prince, and Adam, among the Parliamentarians, found himself a prisoner.

**58** Liverpool in 1664. It was not yet the principal port it was to become in the eighteenth century but it had begun to grow in importance as it was the port which faced the New World.

**59** Thomas Beard, Schoolmaster to Oliver ▶ Cromwell. Education for all children was not possible in the seventeenth century. Indeed, many people even in the upper classes were still illiterate. Grammar schools were open to those who could pay, such as Oliver Cromwell's parents, and in some places free schools, set up by the community, offered a chance for a poor but clever child to acquire some learning.

Prince Rupert was known as a ruthless fighter and although the surrender had been on condition that the citizens were spared Adam noted that

Prince Rupert's men upon their first entrance did (not withstanding these terms) slay almost all they met with, to the number of 360 and, among others . . . some artificers [craftsmen] that never bore arms in their lives.

Adam managed to survive, but he remained a prisoner for nine weeks. This was a frightening time for him, but he kept himself cheerful,

. . . though I lost there . . . all I had: my mare, books, money and cloths and my relations were in such distress as even now I declared. I was sufficiently provided for and my spirits cheerfully supported throughout a tedious imprison- ment . . . though I neither knew where I should be supplied for a week before-hand nor by what means I could expect deliverance.

He was not a soldier and so his release came quite quickly. For the rest of the war he was thankful to return to teaching and found himself a post in Cheshire. He wrote with relief that

**60** "The Master of the School". This picture shows a typical seventeenth-century school for boys *and* girls. Note how most of the children stand for their lessons. While Latin and Greek were still very important the seventeenth century saw the introduction of Science and Mathematics into schools. This was the age of great scholars: men such as Francis Bacon, William Harvey, John Evelyn and Sir Isaac Newton.

This [his teaching post] was a perfect manumission [release] from the hated life I had lived about two years among soldiers: though mine office was all along to employ my pen, not my sword and to spend ink, not spill blood.

Adam continued to study and became a preacher and writer. He married and had six children. He was to suffer imprisonment again in his old age, when he was arrested along with other non-conformist ministers in the reign of James II. He died when he was 63 years old. His part in the war had been typical of many men who did not want to fight and yet found themselves involved in the conflict, often on the side they would not have chosen. Adam defended himself by saying:

If anyone think I should . . . have made some other shift and not have come among them [the Parliamentary troops] let him consider one, how young I was and two, what straits I was in.

# GLOSSARY

**Arminian** A member of a religious group opposed to Puritanism. Arminians' enemies considered their opinions to be too close to those of the Roman Catholic Church.

**The Bishops' Wars (1639 and 1640)** Name given to wars which broke out when Charles I and William Laud tried to enforce the structure of the Church of England on the Scots. The Presbyterian Scots crossed the border into England making it necessary for Charles I to call Parliament.

**Calvinist** A member of one of the various religious groups who followed the teachings of John Calvin, the French religious leader (1509-64). English Puritanism and Scottish Presbyterianism were based on his beliefs.

**The Covenant (or National Covenant)** The document signed by the Scots Presbyterians opposing changes in the Scottish Church. Those who upheld it were known as Covenanters. In 1643 the Covenanters joined Parliament's side, but in 1648 they unsuccessfully supported the King in the Second Civil War. After the execution of Charles I they accepted his son Charles II as ruler of Scotland.

**Episcopal** The government of the Church of England by bishops. Charles I tried to force the Episcopal Prayer Book on the Scots, which led to the Bishops' Wars.

**The Grand Remonstrance (1641)** The document drawn up by the Long Parliament listing the wrongs which they claimed Charles I had committed and proposing remedies for them.

**Impeachment** An old form of accusation brought by the House of Commons against someone close to the King. Henrietta Maria, Thomas Wentworth and William Laud were all impeached.

**The Ironsides** Parliament's first troop of well-trained soldiers, led by Fairfax and Cromwell. Their success at Marston Moor led to Parliament remodelling its entire army. Their enemy, Prince Rupert, first gave them the name "Ironsides".

**The Long Parliament (1640)** Parliament called by Charles I to provide money for the Bishops' War. It cut down the King's power and was the last Parliament before the outbreak of the Civil War. So called because it was not officially dissolved until 1660.

**The New Model Army** Parliament's well-trained and properly disciplined force of 22,000 men founded in 1645. It was responsible for the defeat of the Royalists at Naseby.

**Presbyterian** A Puritan religious group especially powerful in Scotland. Its members believed in government by elected assemblies called presbyteries.

**Puritan** The name given to many different groups of people who wanted to purify the Church. They disagreed on the correct methods of purification.

**The Second Civil War (1648)** This occurred when the Scots changed sides and joined Charles I. They crossed the border to fight the New Model Army but were defeated at Preston.

**The Solemn League and Covenant (1643)** The agreement signed by Parliament with the Scots. The Scots agreed to help Parliament in the Civil War in return for a Presbyterian Church of England.

**The Thirty Years' War (1618-1648)** Major European War over religion and power involving many English soldiers, who brought their experience of tactics and equipment to the English Civil War.

**The Treaty of Ripon (1640)** Treaty negotiated with the Scots to end the Second Bishops' War.

**The "Treaty" of Uxbridge (1645)** An attempt by both sides to end the English Civil War by negotiation. The two sides could not agree and so the fighting went on.

# DATE LIST

| | |
|---|---|
| **1625** | Charles I becomes King of England and marries Princess Henrietta Maria of France. |
| **1626** | The Second Parliament. |
| **1628** | The Third Parliament called. The Petition of Right. The Duke of Buckingham assassinated. |
| **1629** | Eliot's Three Resolutions. Charles dissolves Parliament and begins the eleven years' personal rule. |
| **1633** | Thomas Wentworth beomes Lord Deputy of Ireland. William Laud becomes Archbishop of Canterbury. |
| **1634** | Ship Money levied for the first time. |
| **1637** | John Hampden's Ship Money Case. Charles I introduces the new Prayer Book in Scotland. |
| **1638** | The Scottish National Covenant drawn up. |
| **1639** | The First Bishops' War. The Treaty of Berwick with the Scots. |
| **1640** | Charles I calls the Short Parliament. The Second Bishops' War (the Battle of Newburn and the occupation of Newcastle-Upon-Tyne). The Treaty of Ripon. Charles I calls the Long Parliament. |
| **1641** | The execution of Thomas Wentworth, Earl of Strafford. The Irish Rebellion. The Grand Remonstrance. |

**1642**

| | |
|---|---|
| January | The attempt to arrest the five Members of Parliament. |
| August | The raising of the Royal Standard at Nottingham. |
| October | The Battle of Edgehill. Royalist headquarters set up at Oxford. |
| November | The defence of London at Turnham Green. |

**1643**

| | |
|---|---|
| June | The Battle of Adwalton Moor. The death of John Hampden at Chalgrove Field. |
| July | The Royalist capture of Bristol. The Battle of Roundaway Down. |

| | |
|---|---|
| September | The First Battle of Newbury. The relief of Gloucester. Parliament sign the Solemn League and Covenant with the Scots. |
| December | The death of John Pym. |

**1644**

| | |
|---|---|
| January | The Scots' Covenanters' Army crosses the border into England. |
| June | That Battle of Copredy Bridge. |
| July | The Battle of Marston Moor and the surrender of York. |
| September | The Battle of Lostwithiel. The Battle of Tippermuir (Montrose). The Battle of Aberdeen (Montrose). The Second Battle of Newbury. |

**1645**

| | |
|---|---|
| February | The Treaty of Uxbridge attempted. The Self Denying Ordinance. The formation of the New Model Army. The Battle of Inverlochy (Montrose). |
| June | The Battle of Naseby. The Battle of Langport. |
| August | The Battle of Kilsyth (Montrose). |
| September | The surrender of Bristol. The Battle of Philiphaugh (Montrose defeated). |

**1646**

| | |
|---|---|
| May | Charles I surrenders to the Scots at Newark, marking the end of the First Civil War. |
| June | The surrender of the Royalist head-quarters at Oxford. |

**1647**

| | |
|---|---|
| January | The Scots hand Charles I over to Parliament. |
| June | The Heads of Proposals (an attempt by the Army to make peace with Charles). |
| November | Charles escapes to the Isle of Wight. |
| December | Charles signs "The Engagement" with the Scots. |

**The Second Civil War** (1648)

| | |
|---|---|
| **1648** | The Second Civil War ended by the defeat of the Scots at the Battle of Preston. |
| **1649** | |
| January | The execution of Charles I. |

# BIOGRAPHICAL NOTES

**Campbell,** Archibald, Earl of Argyll (1598-1661). Leader of the Scots' Covenanters during the Civil War and the opponent of Montrose. He supported Charles II after the Civil War but was eventually accused of treason and executed.

**Cavendish,** William, Duke of Newcastle (1592-1676). One of Charles I's most important generals until 1644, commanding the Royalist army in the North. After the defeat of the Royalists at Marston Moor he fled abroad, returning to England in 1660.

**Stuart,** Charles (Charles II) (1630-1685). Eldest son of Charles I and Henrietta Maria. Escaped to France in 1646 and spent the next 14 years in exile, except for a brief return to England in 1650 when his forces were defeated. In 1660 he finally returned to England as King Charles II and reigned for 25 years.

**Cromwell,** Oliver (1599-1658). Leader of Parliament's forces during the war and instrumental in the formation of the New Model Army. After the War he ruled England with the power of the army behind him until his death. From 1649 to 1658 he attempted to achieve a satisfactory alternative to monarchy but failed because of dissension among the different groups.

**Devereux,** Robert, Earl of Essex (1591-1646). A Parliamentary aristocrat, who initially commanded Parliament's forces. His cautious behavior as a general and attitude of conciliation with the King made him unpopular and he resigned in 1645.

**Hyde,** Edward, Earl of Clarendon (1609-1674). Supported Charles I during the war and joined Charles II while the latter was in exile. In 1660 he returned to England as the new King's first chief minister. Author of the *History of the Great Rebellion* (first printed in 1702).

**Laud,** William, Archbishop of Canterbury (1573-1645). Governed the Church of England during Charles I's personal rule. He was an Arminian and, therefore, most unpopular with the Puritans. His attempt, with the King, to force the Episcopal Prayer Book on the Scots led directly to the Bishops' Wars. He was impeached and imprisoned by the Long Parliament in 1640 and later executed.

**Leslie,** Alexander, Earl of Leven (1580?-1661). Commanded the Scots' Covenanters during the Bishops' Wars and played an important part in the Covenanting Army's English missions. After Charles I was executed he became a Royalist and was imprisoned as such by Parliament 1651-4.

**Milton,** John (1608-1674). The great Puritan poet of the seventeenth century. He supported the execution of the King and the establishment of the republic. He was Secretary to the Council of State until 1660. His greatest works, *Paradise Lost, Paradise Regained* and *Samson Agonistes* were published at the end of his life.

**Monck,** George, First Earl of Albermarle (1609-1670). A Royalist who became a Parliamentarian. He governed Scotland for Parliament from 1651 to 1660. He took an active part in the restoration of the King.

**Wentworth,** Thomas, Earl of Strafford (1593-1641), a former Parliamentarian who changed sides, was Charles I's chief adviser during his personal rule (1629-1640). He was impeached by the Long Parliament in 1640 and executed the next year.

# BOOKS FOR FURTHER READING

**Introductory Books**

J.L. Davies (ed.) *Jackdaw: The English Civil War* (Jonathan Cape)

M.A.R. Graves, *England under the Tudors and Stuarts* (Bell and Hyman, 1984)

E.K. Milliken, *The Stuarts* (Harrap, 1959)

E. Murphey, *Then and There: Cavaliers and Roundheads* (Longman, 1979)

L.E. Snellgrove, *The Early Modern Age* (Longman, 1984)

**More Advanced Reading**

John Adair, *By the Sword Divided* (Century, 1983)

John Aubrey, *Brief Lives* (reprinted Penguin, 1982)

Clarendon, *Selections from the History of the Rebellion and the Life by Himself* (reprinted Oxford University Press, 1974)

T. Eustace, *Statesmen and Politicians of the Stuart Age* (Macmillan, 1985)

Antonia Fraser, *The Weaker Vessel. Women's Lot in Seventeenth-Century England* (Methuen, 1985)

J.S. Millward, *Portraits and Documents of the Seventeenth Century* (Hutchinson, 1968)

Austin Woolrych, *Battles of the English Civil War* (Batsford, 1961)

**Books about Particular People**

John Adair, *John Hampden Patriot* (Macdonald and James, 1976)

Antonia Fraser, *Oliver Cromwell, Our Chief of Men* (Weidenfeld & Nicolson, 1973)

Elizabeth Hamilton, *Henrietta Maria* (Hamish Hamilton, 1976)

J.H. Hexter, *The Reign of King Pym* (Cambridge University Press, 1941)

Lucy Hutchinson, *The Life of Colonel John Hutchinson* (Everyman, 1973)

P.L. Ralph, *Sir Humphrey Mildmay* (Rutgers Studies in History, 1947)

G.A. Thomson, *Warrior Prince: Rupert of the Rhine* (Secker & Warburg, 1976)

# INDEX